The Campus History Series

SAINT PETER'S COLLEGE

The Campus History Series

SAINT PETER'S COLLEGE

JOSEPH MCLAUGHLIN AND THOMAS MATTEO

ARCADIA
PUBLISHING

Published by Arcadia Publishing
Charleston SC, Chicago IL, Portsmouth NH, San Francisco CA

Printed in the United States of America

Library of Congress Catalog Card Number: 2009933618

For all general information contact Arcadia Publishing at:
Telephone 843-853-2070
Fax 843-853-0044
E-mail sales@arcadiapublishing.com
For customer service and orders:
Toll-Free 1-888-313-2665

Visit us on the Internet at www.arcadiapublishing.com

CONTENTS

ACKNOWLEDGMENTS

This tribute to Saint Peter's College would not have been possible without the support and cooperation of many people. Within the college community, there was Dr. Eileen Poiani, the vice president for Student Affairs; John Wrynn, S.J., the rector of the Saint Peter's Jesuit Community; Mary Kinahan-Ockay, the college's archivist; Catherine Mernar, from the Office of College Communications; and Michele Lacey, director of Web Strategies and Communication. In addition, there were people outside the Saint Peter's immediate family whose contributions were also significant, particularly John Beekman, the assistant manager of the Jersey Room in the Jersey City Free Public Library; Cynthia Harris, the Jersey Room's manager; and David Sambade, the student archivist at Saint Peter's Prep. Most of the images used in this book came from the archives of Saint Peter's College; however, thanks must also be given to the Jersey City Free Public Library and Saint Peter's Prep for their permission to use several images that were integral to telling this story. Unless otherwise noted, all the images come from the Saint Peter's College Archives.

Gratitude also must go to those whose scholarship and publications proved invaluable to us. In particular are Raymond A. Schroth, S.J., *Will Durant's Religion: Seminary, Exile, "Return"*; Robert I. Gannon, S.J., *The Poor Old Liberal Arts*; Richard J. Cronin, S.J., *The Closing and Reopening of Saint Peter's College: 1918–1930* and *The Jesuits and the Beginning of Saint Peter's College*; Jim O'Donnell, *The Young Estate: A Book about Saint Peter's College*; and Mary Kinahan-Ockay, *Saint Peter's College*. Their efforts have helped to preserve, for generations to come, the rich history of a unique place we call Saint Peter's College.

Finally, we want to thank Dr. Eugene J. Cornacchia, president of Saint Peter's College, whose belief and support of this project never wavered.

INTRODUCTION

Saint Peter's College opened its doors to 71 young men in the fall of 1878. Today the college's enrollment has grown to over 3,000 young men and women in both undergraduate and graduate courses. The growth and development of the college is a testament to the men and women who have served the institution as faculty, administrators, and students. Saint Peter's College was originally located on Grand Street in downtown Jersey City. It briefly moved to the Chamber of Commerce building on Newark Avenue before finding a permanent location on the site of the former Young Estate on Hudson Boulevard in 1936. The college closed from 1918 to 1930. Its rebirth in 1931 was guided by Rev. Robert Gannon, S.J., who envisioned the college as the center of higher education in the New York metropolitan area. In 1966, the college became fully coeducational when women were admitted to the day session. Since the 1960s, the college has grown from a small liberal arts college to a comprehensive institution of higher education, offering graduate programs in four areas. No longer a commuter college, the campus has seven resident halls and a diverse population of students from over 60 nations of origin. Throughout the changes, Saint Peter's College has consistently offered its students an education based on the fundamental values of academic excellence, leadership, service, and faith. The mission, which is grounded in the Jesuit tradition, strives to prepare each student for a lifetime of learning and service.

Saint Peter's College is more than a group of buildings on Kennedy Boulevard; it is the sum of the experiences of all who have been fortunate enough to spend some time there. This book attempts to document these experiences with photographs and commentary, which will provide the reader with an insight to the grandeur of this humble, yet wonderful place.

One

THE BIRTH OF A COLLEGE

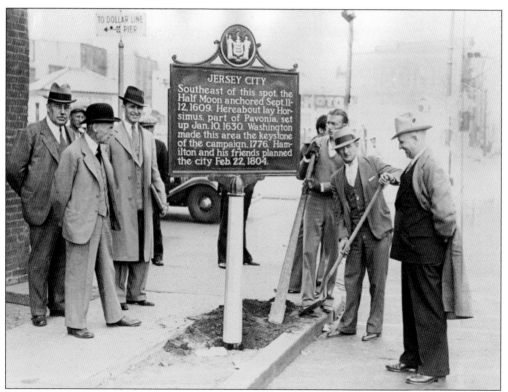

By 1871, Jersey City's population was 80,000, of which 30,000 were Catholic. Most of these inhabitants lived in what is now called downtown. In addition, downtown was the center of commerce and the home of Saint Peter's Church. There were seven other churches in town. Some had an elementary school, but none had an institution of higher learning. This would soon change.

In the early 1800s, Catholics in Jersey City had to travel to Manhattan to attend mass. The first mass was offered in Jersey City in 1829 in a makeshift church. St. Michael's Episcopal Church offered their building for temporary use until a Catholic church could be built. In 1831, Saint Peter's Church was incorporated under the jurisdiction of the New York Diocese. In 1837, Saint Peter's Parish was located on Grand Street between Warren and Washington Streets. It had a modest church and a school. At that time, it had four priests and about 100 parishioners. In 1853, the Diocese of New Jersey was created, and throughout the 1850s, the church grew due to the large number of Irish immigrants who settled in the downtown section of Jersey City because of its proximity to New York City.

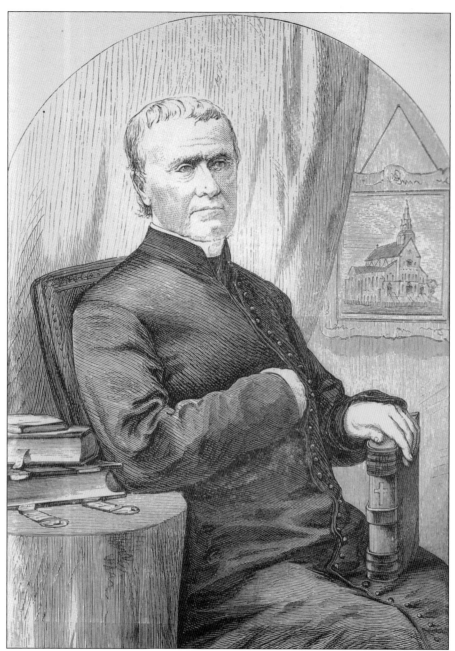

In 1844, Fr. John Kelly became the pastor of the parish and Jersey City became part of Hudson County. The city was growing by leaps and bounds as Irish immigrants fled the potato famine in Ireland. When he began his work, there were only 500 Catholics in the parish. Father Kelly responded to the needs of his growing flock by developing plans to expand the parish. In 1861, he erected a school on the corner of York and Van Vorst Streets. In 1863, he purchased lots on Grand Street for a new and larger church. Construction began in 1865, but Father Kelly died the following year before the church was completed. By the time of his death in 1866, the number of parishioners had grown to 6,000. Father Kelly was known as the "Apostle of Jersey City." (Courtesy of the New Jersey Room, Jersey City Free Public Library.)

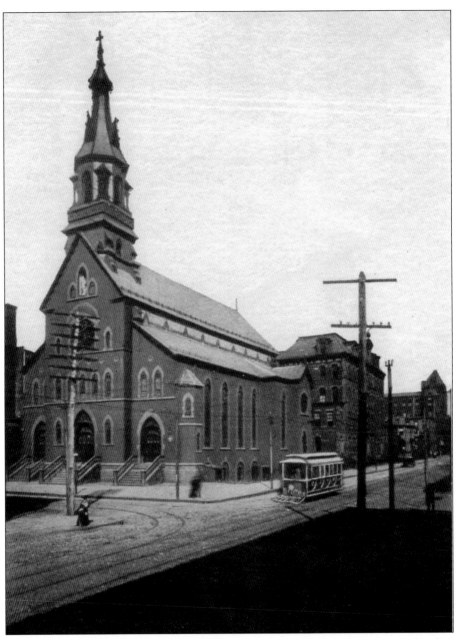

Bishop James Roosevelt Bayley, the Bishop of Newark, wanted the Jesuits to come to his diocese. In 1870, he sent a letter to Rev. John Bapst, S.J., one of the superiors of the New York-Canada Mission, inviting him to come to Saint Peter's Parish in Jersey City to open a college. At this time, the church was in considerable debt. Father Bapst was willing to take over the parish but did not want to start a college until all the parish's debts were paid. The Jesuits took over Saint Peter's Parish on April 13, 1871. Rev. Victor Beaudevin, S.J., was named the first superior and pastor. Some 15 Jesuits were assigned to Saint Peter's from 1871 to 1878. On April 13, 1872, a college charter was granted to Saint Peter's by a special act of the legislature of New Jersey. Father Beaudevin was named president. The board of trustees purchased land at Grand and Van Vorst Streets on July 26 to be the home of the future college.

Rev. John McQuaid, S.J., was made superior of the Jesuits at Saint Peter's on July 31, 1874. The Bishop of Newark was eager for the Jesuits to start to build the college; however, according to Father Bapst's original plan, the construction of the college could not begin until the entire debt of the parish was paid. The depression of 1873 to 1878 contributed to the parish's slow progress toward making their payments. In 1877, Father McQuaid took heed of the Bishop's wishes and began construction of the college. On September 2, 1878, Saint Peter's College classes began with 71 students whose ages ranged from 10 to 15. The enrollment grew to 123 by the end of the school year. Most students were Irish and came from downtown Jersey City. None of the first students started a college program as it is known today.

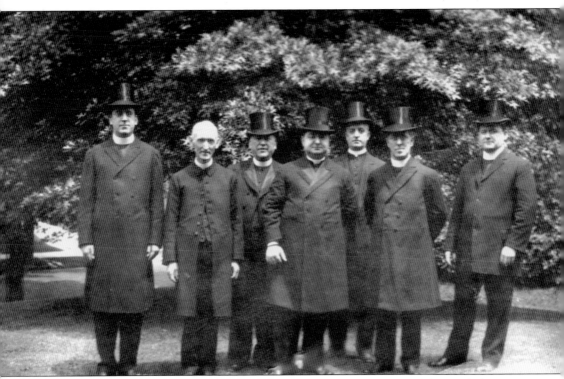

In the first year, there were six Jesuits on the faculty—three priests and three scholastics. Rev. George Kenny, S.J., was the prefect of Studies and Discipline. Rev. John McQuaid, S.J., was the treasurer of the college and was later named the second president of Saint Peter's College in 1880. Other Jesuits on the first faculty were Rev. Charles O'Connor, S.J., and Rev. Ignatius Renaud, S.J. The three scholastics were Francis Gunn, S.J.; Robert Parlow, S.J.; and James Smith, S.J. The men who founded Saint Peter's College came from the United States and six different countries in Europe. Saint Peter's strength then, as it is today, was its diversity of nationalities, all of which were working to make the college a center of learning for the students of Jersey City. They were dedicated men who worked hard for their students and, in turn, demanded that their students work hard for them. In many ways, the relationship between the faculty and students remains the same today.

In the 1889–1900 academic year, the tuition for Saint Peter's College was $10.25 per quarter or $41 per year, plus fees. The curriculum was strictly liberal arts. The course of study included a heavy dose of Greek and Latin in the freshman and sophomore years.

TERMS: PAYABLE IN ADVANCE.

Entrance Fee....................................... $5.00

Tuition, including use of Library, per Quarter....... $10.25

In the Sophomore and Junior years there is a charge of $10.00 per annum for the use of chemicals.

Graduation Fee.................................... $10.00

1st Quarter begins...............First Tuesday in September.

2d Quarter begins...........................November 16th.

3d Quarter begins............................February 1st.

4th Quarter begins.............................April 15th.

N. B.—No deduction will be made for absence from any part of a Quarter unless attendance is prevented for some notable length of time by sickness or a cause equally serious.

TIME SCHEDULE.

Collegiate Department.

FRESHMAN.	Hours.
Latin	5
Greek	4
English (Precepts, Authors)	4
History	2
Mathematics	4
Christian Doctrine	1
Elocution	1
Modern Languages	2
	23

SOPHOMORE.	Hours.
Latin	5
Greek	4
English (Precepts, Authors)	4
History	2
Mechanics (1st Term), Geology and Astron (2nd Term)	4
Christian Doctrine	1
Elocution	1
General Chemistry	2
	23

JUNIOR.	Hours.
Philosophy	5
Latin	2
Greek	2
English	2
Physics	5
Philosophy of History	2
Christian Doctrine	1
Elocution	1
	20

SENIOR.	Hours.
Psychology and Nat. Theology	5
Ethics	5
Latin	2
English	2
History of Philosophy	2
Political Economy	1
Christian Doctrine	1
Elocution	1
Physiology	1
	20

The Schedule for Junior and Senior years calls for only twenty hours of class work a week. This is desirable for students of the higher classes, as their studies are more exacting and require greater preparation.

Optional studies may be added to these hours for those who wish to take them

In junior year, studies were expanded to include philosophy and physics. Ethics, psychology, and political economy were introduced to seniors. Mathematics remained a constant throughout the four-year program. Partly due to the rigorous liberal arts education they received, many graduates of the college from that era went on to be judges, congressmen, and other influential members of the community.

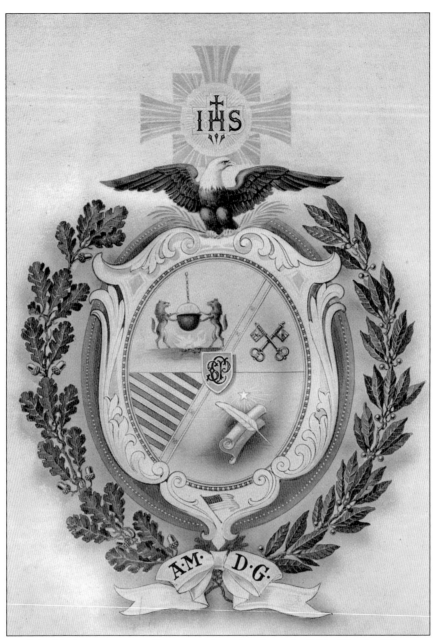

The original shield of Saint Peter's College was adapted in the early 1900s. The shield bears symbols that signify Jesuit values. The wolves signify keeping the wolf from the door of the poor; the quill represents the belief that the pen is mightier than the sword; the lettered roll signifies classical learning; the star reminds all that true learning comes from above. The lines or "bends" represent the house of Onez, part of the House of Loyola. The wreath contains the oak of civic merit and laurels of classic lore. In the center of the shield are the initials C.S.P., *Collegium Sancti Petri*, which translates as "Saint Peter's College." The initials above the bald eagle of the United States, I.H.S., proclaim Jesus Christ Savior of Men, and the keys represent the significance of their patron, Saint Peter the Apostle. Finally, the initials A.M.D.G. at the bottom stands for *Ad Majorem Dei Gloriam*, which translates as "for God's greater glory," the motto of Saint Ignatius, the saint-solider.

On July 2, 1902, Rev. James Fox, S.J., became president of the college and pastor of Saint Peter's Church. Although the enrollment of the college was good, Father Fox had the idea to start a school that would train young boys for the rigors of college. In August 1905, Father Fox bought Manresa Hall on the corner of Summit Avenue and Montgomery Street (the site of the present day Jersey City Armory). He made it a private grammar school and appointed Rev. Edward Brock, S.J., as principal. The school was a quasi-military academy for the boys of middle to upper class families. (Both courtesy of Saint Peter's Prep.)

The school's mission stressed obedience, academic excellence, and physical activities. The Jesuits have always felt that physical education has an important role in the education of youth. At Manresa, athletics, outdoor sports, and gymnastics contributed to the physical health of its students. It was believed that physical health helped develop steadiness, self-reliance, self-control, and the ability to subordinate the personal concerns for the common good. (Both courtesy of Saint Peter's Prep.)

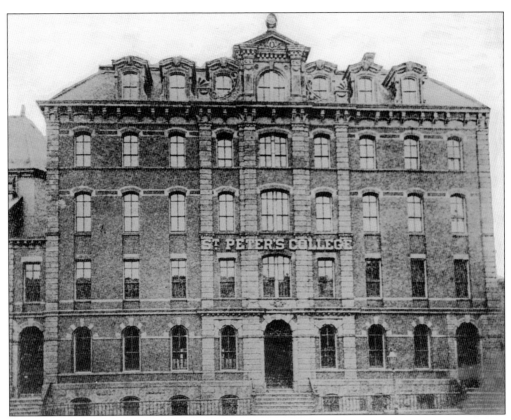

From 1888 to 1891, Rev. Peter Cassidy, S.J., was president of Saint Peter's College. He presided at the first graduation on June 22, 1889, when four students received degrees. Enrollment steadily increased to 261 students in the 1895–1896 academic year. This constituted a great leap forward from 123 in 1878. It is especially significant because by 1900 only four percent of college-age adults attended college.

In a time when few young men attended college, Saint Peter's College, by 1900, had granted 63 bachelor of arts degrees and 26 master of arts degrees. It had established itself as a center of higher education for the young men of Jersey City and the neighboring communities in Hudson County. In this 1897 photograph, the senior class poses for its graduation picture.

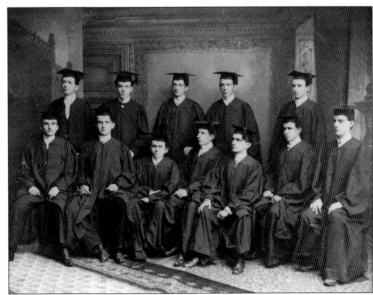

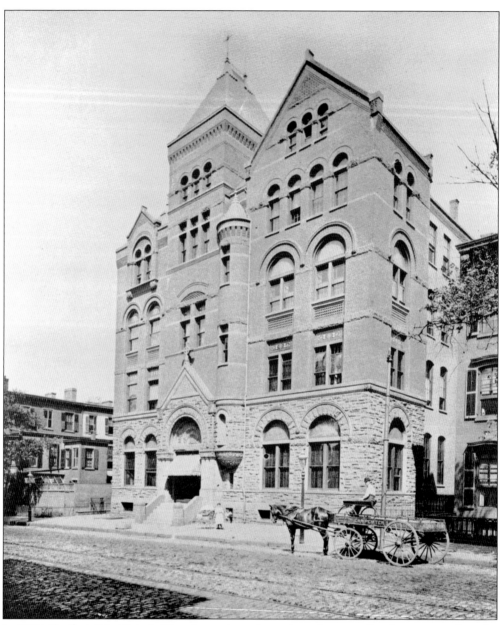

In 1889, the first Saint Peter's Church was torn down to make room for the construction of a new building for the St. Aloysius Academy. The academy was operated by the Sisters of Charity of Saint Elizabeth as a private Catholic school for women. The Sisters of Charity moved the school to 2495 Kennedy Boulevard where it stayed until it closed in 2005. Saint Peter's Prep obtained the building and named it the Science, Freshman, and English Building. It was renamed the Humanities Building. In 1995, it received a multimillion dollar face-lift to update its facilities. The improvements included a floor-to-ceiling renovation of its Siperstein Library and the installation of a CD-ROM computer center for research and word processing on the first floor. The lower level houses physical education facilities and the upper three floors are devoted to classrooms and an art studio.

In 1905, Saint Peter's College and Saint Peter's Prep were recognized by the New Jersey State Board of Education and registered in Trenton as maintaining a full four years college and academic course. There was no real distinction between the high school and college that were housed in the same building. The course of studies was seven years and included what is now known as high school. The two schools were not separately incorporated until February 1955. By the 1913–1914 academic year, the college and prep had a total student enrollment of 415. Because there was no distinction between the two schools, the athletic teams played a schedule that combined both local high schools and colleges from the metropolitan area. It was not uncommon for the basketball team to play Cooper Union in New York City one week and Dickinson High School in Jersey City the next.

HOME		ABROAD	
Bayonne H. S.	Jan. 4	St. Francis College	Nov. 26
Fordham Prep.	Jan. 11	Montclair Acad.	Dec. 13
Dickinson H. S.	Jan. 18	Dickinson H. S.	Dec. 15
Manhattan Prep.	Jan. 30	Brooklyn Prep.	Jan. 9
Brooklyn Prep.	Feb. 1	Blair Acad.	Jan. 12
St. John's Prep.	Feb. 22	St. John's Prep.	Jan. 15
Emerson H. S.	Feb. 27	Bayonne H. S.	Jan. 26
Hoboken H. S.	unsettled	Lakewood H. S.	Feb. 2
Morristown	unsettled	Stevens Prep.	Feb. 5
St. Francis College	unsettled	Fordham Prep.	Feb. 9
		Cooper Union	Feb. 13
		St. Francis Xavier	Feb. 20
		Passaic H. S.	Mch. 9
		Emerson H. S.	Mch. 15
		Morristown	Mch. 22

PENDING—Peddie, Hoboken, DeWitt Clinton, Horace Mann, Cliffside, N. Y. U. Freshmen, Princeton Prep.

Will Durant
5608 Briarcliff Road
Los Angeles, Calif. 90068

5-23-77

Dear Mr Cardiello:

 I am not sure whether I
answered your letter of April 13¢ or not.
t/ I do not recall any specific inviation to
Ariel and myself to attend the 100th anniver-
sary pf St. Peter's College. If I rceived
one I should have been glad to attend, for I
have never ceased to love and honor my Jesuit
teachers of 1900-17, and to acknowledge my
debt to them.

 Sincerely,

 Will Durant

When Will Durant came to Saint Peter's College at the age of 15 in September 1900, he possessed a keen mind and a strong desire to pursue an academic program of studies. Little did anyone know that he would become one of Saint Peter's most celebrated alumni and that his works *The Story of Philosophy* (1926) and the 11-volume *The Story of Civilization* (1935–1973), which was written in collaboration with Ariel Durant, would live on long after his death in 1981. Will graduated from Saint Peter's College in 1907 and received an honorary degree on May 22, 1979. He always held dear his relationship with the Jesuits of Saint Peter's and the educational foundation that they afforded him.

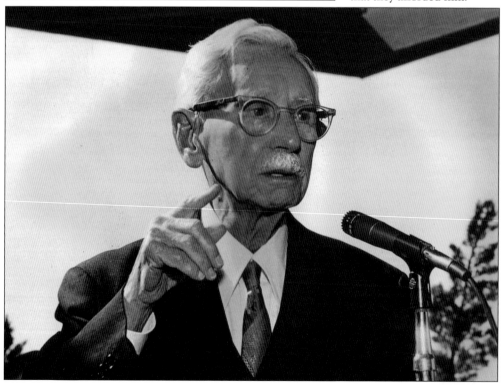

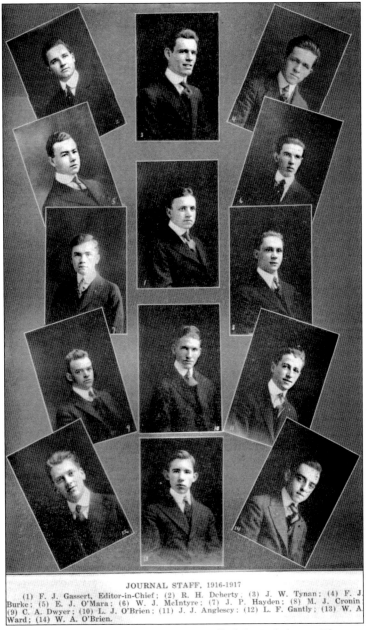

JOURNAL STAFF, 1916-1917

(1) F. J. Gassert, Editor-in-Chief; (2) R. H. Doherty; (3) J. W. Tynan; (4) F. J. Burke; (5) E. J. O'Mara; (6) W. J. McIntyre; (7) J. P. Hayden; (8) M. J. Cronin; (9) C. A. Dwyer; (10) L. J. O'Brien; (11) J. J. Anglescy; (12) L. F. Gantly; (13) W. A. Ward; (14) W. A. O'Brien.

In March 1911, students started a literary magazine called the *Ephebeum*. The magazine, which was later renamed the *Saint Peter's College Journal*, is of historical significance because it is the earliest record of Saint Peter's College students' writing. This magazine started a strong tradition of documenting students' writing about their thoughts and experiences while they were at the college. This is a photograph of the staff of the 1916–1917 journal staff. F. J. Gassert (1) was the editor-in-chief of this staff, which included R. H. Doherty (2), J. W. Tynan (3), F. J. Burke (4), E. J. O'Mara (5), W. J. McIntyre (6), J. P. Hayden (7), M. J. Cronin (8), C. A. Dwyer (9), L. J. O'Brien, L. J. Anglescy (11), L. F. Gantly (12), W. A. Ward (13), and W. A. O'Brien (14). Today the literary magazine is called the *Pavan*. It has been expanded to include students' drawings, paintings, and photographs.

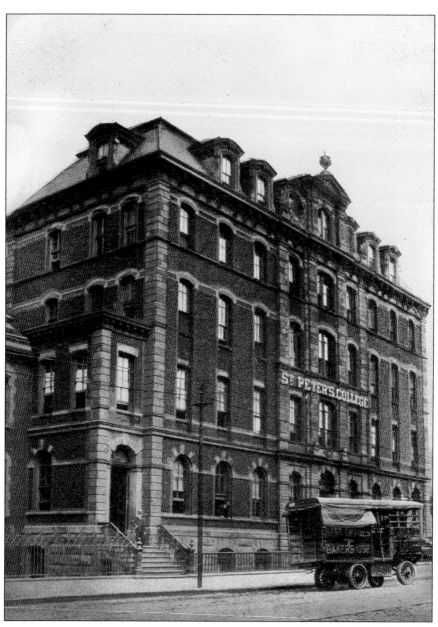

In the academic year 1913–1914, Saint Peter's College and Prep were booming. Combined enrollment rose to 415. The college had fielded a football team. The team was not very successful, and one student lamented that the team's latest game against Seton Hall "we were defeated 14-6 as usual." The college, however, was excelling academically, attracting students from all over. Their reputation for academic excellence enabled the college to expand its base of recruitment and for students to come from areas outside of Jersey City for a Jesuit education. For the first time, the college was starting to create its own identity outside Saint Peter's Parish. However, in a few short years, this time of prosperity would come to an end with the start of World War I. While a few students were permitted to complete their education, most went on to other colleges like Seton Hall and Fordham to complete their studies. The college virtually closed its doors until 1930.

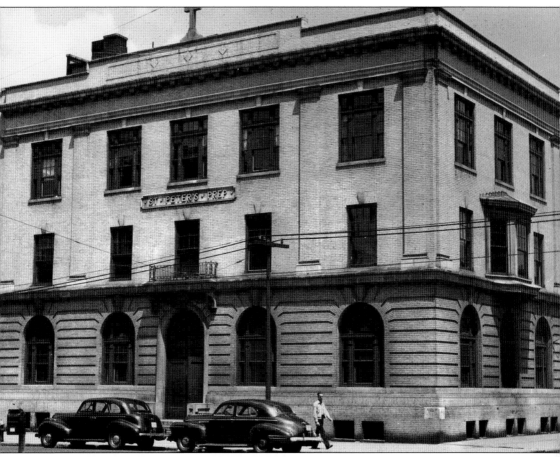

On June 22, 1913, a cornerstone was placed into the Saint Peter's Club, a former social club, which was situated on the corner of Grand and Warren Streets. Rev. Joseph Mulry, S.J., the college president from 1911 to 1915, obtained the building to fulfill two needs: to advance the moral and ethical welfare of his students and to provide more room for the growing student enrollment. Part of the building was used as classrooms for the high school students and another part for social events. A motion picture was shown one night a week. It functioned in this way until Saint Peter's Prep took possession of it after the college closed in 1918. The prep transformed it into a classroom facility and renamed it Mulry Hall. Today it houses the prep's administrative offices, student counselors' offices, classrooms, and the College Placement Center.

St. Peter's College

Jersey City, N. J.

Commencement Week, 1918

Saturday, June 15th

Closing Mass, Communion and Breakfast

St. Peter's Church, 8:15 A.M.

Address: Rev. James F. McDermott, S. J.

Monday, June 17th

High School Debate and Closing Exercises

St. Peter's Hall, 8 P.M.

Address: Philip J. Marnell, A.M., LL. B.

Wednesday, June 19th

College Commencement and Alumni Re-union

St. Peter's Hall, 8 P.M.

Address: Hudson Maxim, LL. B.

Thursday, June 20th

Manresa Hall Prize-Night and Graduation Exercises

St. Peter's Hall, 8 P.M·

Address: Charles M. Egan, LL. B.

The 1918 commencement exercises were the last one for Saint Peter's College until 1934. At the end of the 1918 academic year, the college closed because of World War I. Another reason for the college's closing involves Rev. William Rockwell, S.J., the provincial of the Newark Archdiocese Jesuits. Father Rockwell wanted to close down the smaller Jesuit colleges and work on expanding the larger ones. Rev. James McDermott, S.J., the president of the college from 1915–1921, did not think that Saint Peter's would be affected because Father Rockwell had promised to keep the college open if it acquired a new site with athletic facilities. Father McDermott completed a deal to purchase the site on Kennedy Boulevard where New Jersey City University now stands for $100,000. The deal was financed and ready to go when Father Rockwell decided to close the college for its low enrollment and because it was no longer possible to assign the college a full Jesuit faculty. The first chapter of Saint Peter's College comes to an end.

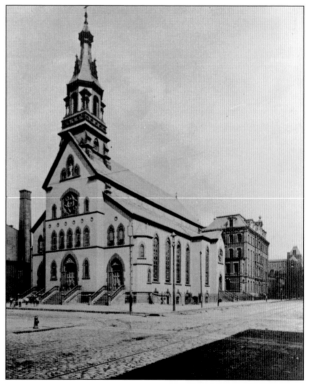

Two

THE REBIRTH OF
SAINT PETER'S COLLEGE

Rev. Robert Gannon, S.J., the dean of the resurrected Saint Peter's College, envisioned Saint Peter's as the center of the New York Metropolitan area. In a brochure that he authored to promote the college, he offered the following description: "We have no scenery, no fraternities, no expensive teams, no easy degrees. But we have hard work and real courses for men who have neither the time nor money to waste."

Rev. Robert Gannon chose the peacock as the college's symbol. In mythology, the peacock burned in flames and was then reborn with greater beauty. Father Gannon believed the myth to correspond with Saint Peter's College's death in the flames at World War I, only to rise again with greater academic beauty in its reopening. In addition, a Dutchman named Michael Pauw bought the land that is presently Jersey City and named it Pavonia, land of the peacock. The seal of Saint Peter's College was designed in 1930. It shows a peacock on a rock, a pair of cross keys, and the words "In perpetuum." The peacock is a symbol of rebirth and immortality; the rock symbolizes Peter; the keys represent the kingdom of heaven; and "In perpetuum" is the hope that the college will live forever. Many of the college's societies and activities are connected to the peacock mythology. The Most Noble of the Peacock, the academic honor society; the *Pauw Wow*, the newspaper; the *Peacock Pie*, the yearbook; and the *Pavan*, the literary magazine, are a few that still exist today.

On September 26, 1930, Saint Peter's held classes for the first time in 12 years. Classes were held on the fourth floor of the Chamber of Commerce building on One Newark Avenue. There were 85 students and 6 faculty members in the first year. In Rev. Robert I. Gannon's book, *The Poor Old Liberal Arts*, a section opens with Father Gannon sitting alone on the roof of the building. He states, "Then and there it was determined, sitting on the roof looking at the linoleum factory, and in full smell of Colgate's down the street, that the new Saint Peter's College would be a novelty in American education. It would offer a first-class liberal arts course and teach only intelligent and ambitious students. In other words, it would give what it ought to give and only to those who ought to get it."

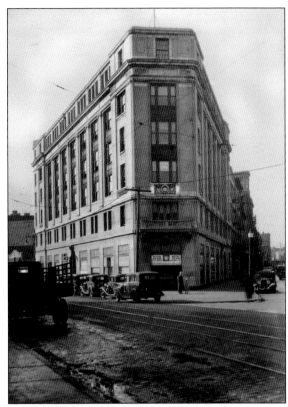

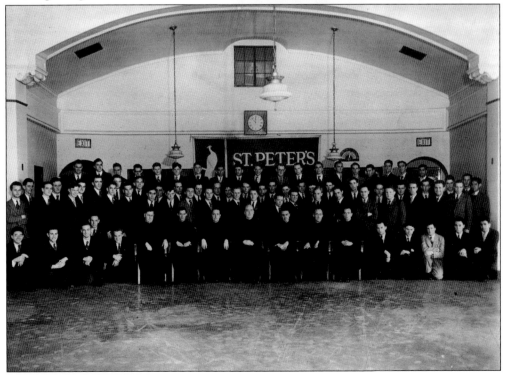

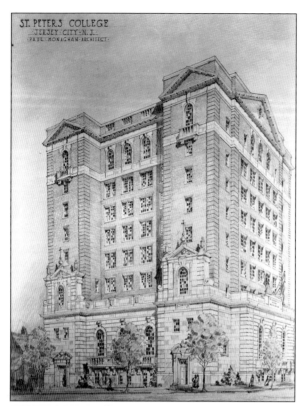

In 1930, the college sold Manresa Hall. This money allowed the college, in 1931, to purchase the Albanesius property on Hudson Boulevard at Lincoln Park for $63,000 as a new home for the college. Paul Monghan, an architect from Philadelphia, was hired to draw plans for a 10-story building to cost $450,000. When bids were taken for construction, total costs were estimated to rise to $880,000. The cost of the project proved to be too expensive, forcing the college to abandon the plans to build on the site. Eventually the land was exchanged for lots on Montgomery and Glenwood Avenue.

In August 1931, Rev. Joseph Dinneen, S.J., (seated, right) was named president of the college. Father Dinneen proved to be an effective fund-raiser. On January 11, 1934, he started his "Buy a Brick" campaign. The first building he wanted to construct was a gym. It made perfect sense to him; after all, the structure could be used to hold fund-raising affairs. The gym was named Collins Gym after Rev. Patrick Marley Collins, who was a teacher and prefect at Saint Peter's College from 1870 to 1934. To Father Dinneen, it was a perfect choice linking the "old" college to the "new" college, which he was determined to build. The rest of his plan included a science hall and a classroom building. He organized a plan to educate the metropolitan area of the good works of Saint Peter's and urged the community to contribute to a building fund that would allow the college to build a permanent home. His actions enabled the college to buy the Young Estate in 1933.

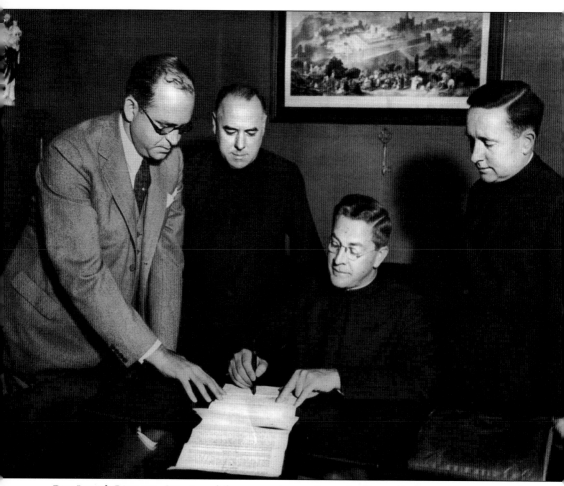

Rev. Joseph Dinneen, S.J., signed the papers to purchase the Young Estate on Montgomery Street and Hudson Boulevard for $200,000 on October 9, 1933. The terms were $100,000 in cash with a balance to be paid over a two-year period with a three percent interest rate. The original asking price was $700,000, which was rejected by the college. Offers poured in from all over Hudson and Bergen Counties. In fact, one property was offered for free but was rejected because it was near the George Washington Bridge and considered not easily accessible. Father Dinneen then purchased the Albanesius Mansion at the entrance to Lincoln Park. He hoped to build a skyscraper similar to what St. John's University built in downtown Brooklyn. This move forced Young to slash his price. After Jersey City agreed to trade the Albanesius property for city lots on Montgomery Street and Glenwood Avenue, the college agreed to purchase the Young property. Although the purchase was a smart business move, the Jesuit provincial was reluctant to have the college borrow money in order to start building. Fund-raising was imperative.

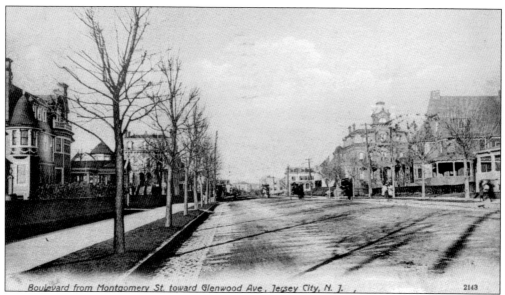

Boulevard from Montgomery St. toward Glenwood Ave., Jersey City, N. J. 2143

The Young Estate extended 303 feet from Montgomery Street to Glenwood Avenue along Hudson Boulevard. It extended 510 feet down Montgomery Street and 125 feet down Glenwood Avenue. It was about two and a half acres, which was seven times the size of the Albanesius purchase on Lincoln Park. Edward Young had originally offered the property to the college when Rev. Joseph P. O'Reilly, S.J., was president of the college in 1930 for $800,000. However, when the college bought the Albanesius property in 1931 with the promise to build a skyscraper, Young reduced the selling price of his estate to $200,000. Without this drastic reduction in price, the college would not have been able to purchase the Young Estate and would have had to look elsewhere to find a home. (Below, courtesy of the New Jersey Room, Jersey City Free Public Library.)

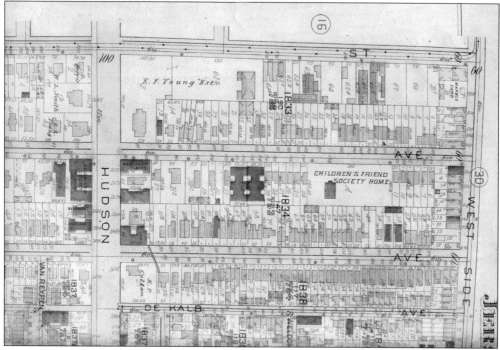

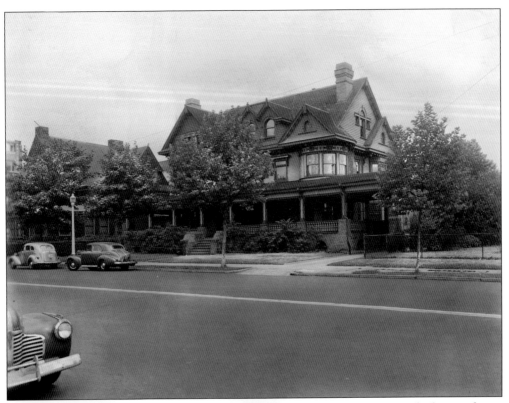

The Young Estate was the home of Edward F. C. Young, Jersey City's wealthiest resident and most powerful financial and political figure in the late 1800s. He was president and director of the Dixon Crucible Company and the North Jersey Land Company. He was an officer of five Jersey City banks and served on the board of directors of several local corporations. Young was also a successful politician. He was elected city treasurer of Jersey City, Jersey City alderman, and a Hudson County freeholder. He unsuccessfully sought the Democratic nomination for governor in 1892. Young was also remembered for his philanthropy and civic pride. He died in his home on Hudson Boulevard on December 6, 1908.

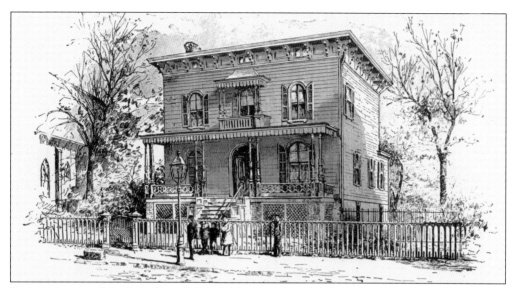

Young was one of the founders of the Children's Home on Glenwood Avenue located between Hudson Boulevard and West Side Avenue. According to the 1900 census report, the home had a staff of six women who lived on site and cared for 39 children whose ages ranged from 5 to 13 years. The home was eventually closed and was developed as a garden apartment complex. In 1984, the college bought the property and renovated it as student residence apartments. Today it is one of the seven residence halls that house approximately one half of the full-time student population on the college campus. (Both courtesy of the New Jersey Room, Jersey City Free Public Library.)

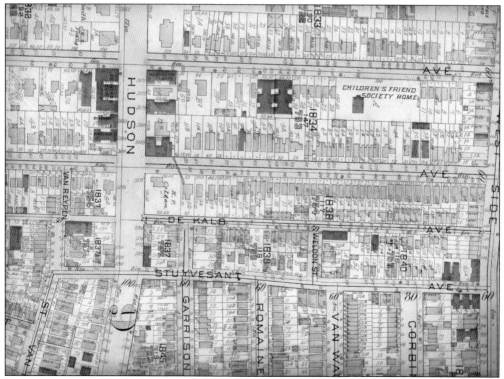

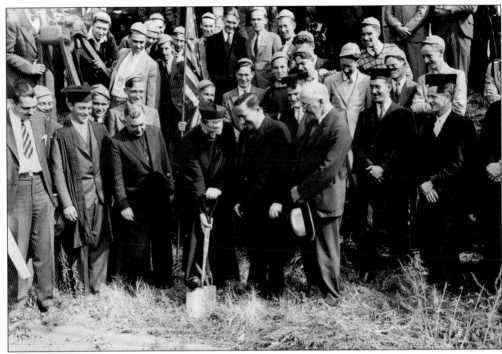

The modern-day Saint Peter's College campus started to develop in 1934. Rev. Joseph Dinneen's fund-raising prowess, which was evidenced in his "Buy a Brick" campaign, started in January. By September, Father Dinneen broke ground for the first building on what was once known as the Young Estate. The building, named after Rev. Patrick Marley Collins, S.J., was a gymnasium. Father Collins was a teacher and prefect at the college from 1929 to 1934. The building, which cost $55,000, was the first in a two-part plan of three buildings that would form the new campus. The other two were a science hall and a classroom building. The second part of the plan included a chapel, library, and faculty residence. In addition to serving as a gym, the building became the site of fund-raising affairs to finance the growth and development of the new campus.

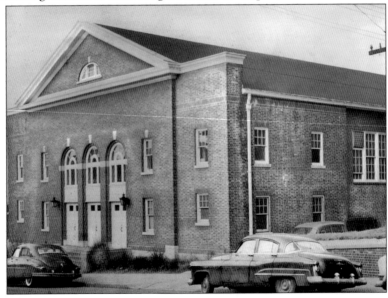

Financial difficulties forced the college to think about alternative means of income. In 1932, Hudson College, an evening business division, was initiated partly as a means to generate income to pay the rent for classrooms in the Chamber of Commerce building. Hudson College was the forerunner of today's School of Business Administration. The initial enrollment was 41 students: 36 men and 5 women. There were seven professors in the first year. By the year's end, there were 63 students and 17 courses. Hudson College was the first in northern New Jersey to offer advanced courses that resulted in a bachelor of commercial science degree. Hudson College's first graduation was in 1936. Two men and three women received their degrees. Hudson College became the School of Business Administration in 1951.

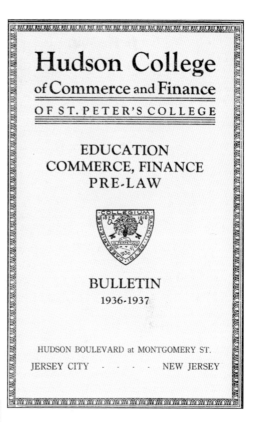

Hudson College
of Commerce and Finance
OF ST. PETER'S COLLEGE

EDUCATION
COMMERCE, FINANCE
PRE-LAW

BULLETIN
1936-1937

HUDSON BOULEVARD at MONTGOMERY ST.
JERSEY CITY · · · · NEW JERSEY

HUDSON COLLEGE OF COMMERCE AND FINANCE

Programs of Study

COMMERCE AND FINANCE
FOUR YEAR COURSE

Freshman Year

FIRST SEMESTER		SECOND SEMESTER	
Principles of Accounting (Acct. 1)	2	Principles of Accounting (Acct. 2-3)	4
Fundamentals of Econ. (Econ. 1)	3	Fundamentals of Econ. (Econ. 2)	3
Business Mathematics (Math. 7)	2	Agency and Partnership	
General Survey and Contracts		(Bus. Law 2)	2
(Bus. Law 1)	2	Cultural	7
Cultural	7		
	16		16

Sophomore Year

FIRST SEMESTER		SECOND SEMESTER	
Advanced Accounting (Acct. 5-6)	4	Advanced Accounting (Acct. 7-8)	4
Philosophy 1	2	Philosophy 2	2
Sociology 1	2	Sociology 2	2
Cultural	4	Cultural	4
Business Elective	4	Business Elective	4
	16		16

Junior Year

FIRST SEMESTER		SECOND SEMESTER	
Business Subjects (elective)	8	Business Subjects (elective)	8
Philosophy 3	2	Philosophy 4	2
Cultural	6	Cultural	6
	16		16

Senior Year

FIRST SEMESTER		SECOND SEMESTER	
Business Subjects (elective)	8	Business Subjects (elective)	8
Philosophy 5	2	Philosophy 6	2
Cultural	6	Cultural	6
	16		16

37

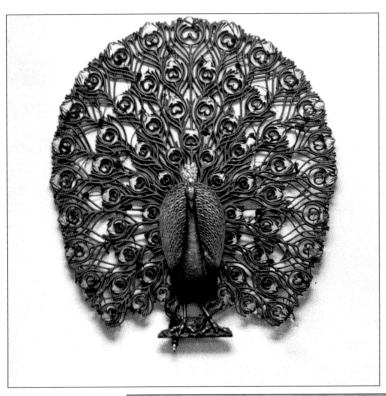

The Most Noble Order of the Peacock (MNOP) was started in 1930. Every year since then, the 10 seniors who have the highest academic averages are admitted to this honor society. The students are inducted into the MNOP at the Michaelmas Convocation, a tradition that was inaugurated by Father Gannon in commemoration of the beginning of the English university academic term.

The Glee Club was founded in 1931 by Frederick Joselyn. Joselyn conducted the group for 25 years. He is also the cocomposer with Richard I. Nevin of Saint Peter's "Alma Mater." Recently the Glee Club has been renamed the Aidan C. McMullen Chorale in honor of its long-standing director and advocate. The mission of the group has remained consistent: to produce good choral music and build a rich musical experience at the college.

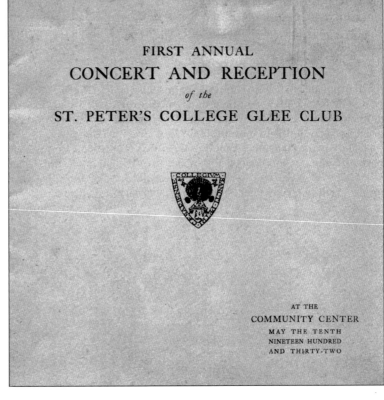

FIRST ANNUAL
CONCERT AND RECEPTION
of the
ST. PETER'S COLLEGE GLEE CLUB

AT THE
COMMUNITY CENTER
MAY THE TENTH
NINETEEN HUNDRED
AND THIRTY-TWO

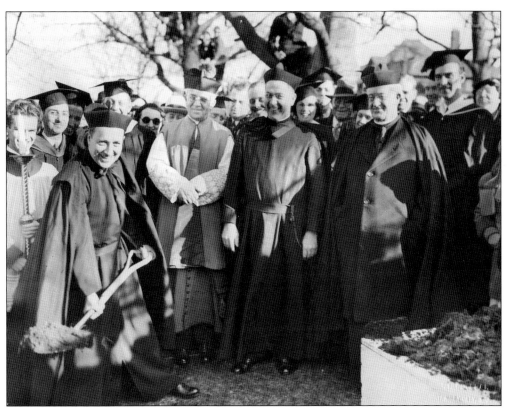

Father Gannon broke ground on March 27, 1936, for the second building on the new campus on Hudson Boulevard, Gannon Hall. In the summer of 1936, Father Gannon, dean of the college since 1930 and the driving force behind the life of the second coming of Saint Peter's College, left his position to become the president and rector of Fordham University. Many cite Rev. Joseph Dinneen, the president, as the fund-raiser and economic genius who made it possible for the reopened college to grow and build. On the other hand, Father Gannon, the dean, is often cited as the soul of the resurrected college. He instituted many traditions that continue today and set the tone for high academic standards with the creation of a rigorous and challenging curriculum.

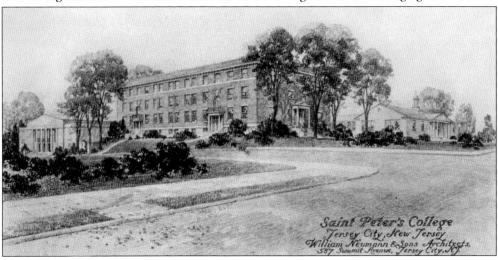

Saint Peter's College
Jersey City, New Jersey
William Neumann & Sons Architects,
587 Summit Avenue, Jersey City, N.J.

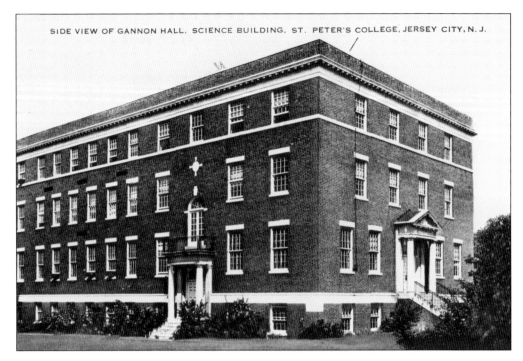

SIDE VIEW OF GANNON HALL, SCIENCE BUILDING, ST. PETER'S COLLEGE, JERSEY CITY, N. J.

Classes started on the present site of the college on September 24, 1936. Some 400 students, 20 Jesuits, and 20 lay teachers filled Gannon Hall and the Arts Building. Gannon Hall, a four-story colonial brick and limestone building, set the tone for the architectural style of future buildings on campus. Today Gannon Hall is home to the sciences. The Arts Building was one floor of temporary classrooms. It was affectionately known as "the Railroad Hall" and "the Bowling Alley" because of its unique shape. The Arts Building was razed in the mid-1950s to make way for the future Dinneen Hall.

SAINT PETER'S COLLEGE, JERSEY CITY, N. J.

Father Gannon initiated the tradition that seniors should wear the short Cambridge undergraduate gowns to class and on campus. In 1930, when Father Gannon was appointed the dean of the college, he had just returned from graduate studies in English at Cambridge University. In a small way, this was Father Gannon's way of trying to bring a touch of the Cambridge tradition to the college on Hudson Boulevard. This tradition, which lasted into the 1960s, gave the seniors a distinct presence on the campus and created a sense of sophistication. The robes were a constant reminder to the students and faculty of Father Gannon's vision to make Saint Peter's an outstanding academic institution.

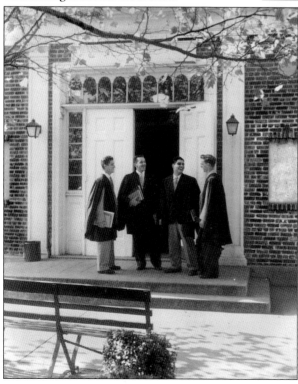

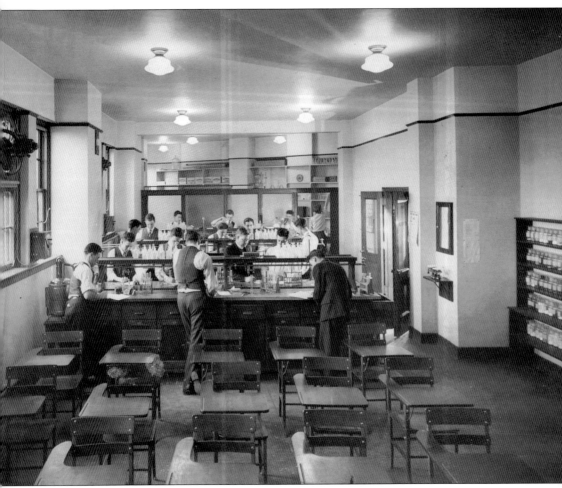

In 1936, the Collins Chemistry Society was founded in honor of Rev. Patrick Marley Collins, S.J., who for many years was connected with the Science Department of the college. It was established to help students love the sciences, especially chemistry, and to help the student members to understand that science is never-ending. This society and the state-of-the-art labs that the Saint Peter's College built in the 1930s were the origin of its reputation as an excellent premed institution. Father Collins believed that scientists are members of a family and that they are not only judged by what they do but by the way in which they carry themselves in life. The goal of each member in the society is to solve the hardest problems in the world, to help people find cures and establish a better world for all.

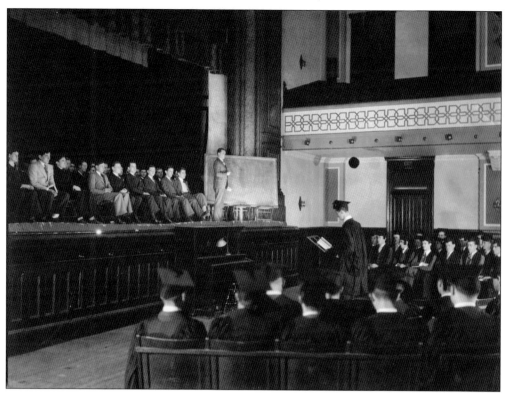

Classes started on the present site of Saint Peter's College on September 24, 1936. Freshmen were required to wear beanies and were subject to the whim of sophomores. By June 1937, Saint Peter's College graduated its largest class of that era. It was the second graduation at its new campus on Hudson Boulevard in Collins Gym. By this time, the college had received students from over 100 high schools, cities, and towns from all over New Jersey and beyond. The enrollment was significantly more diverse both in terms of academic and geographic background than the college had seen from 1919 to 1930.

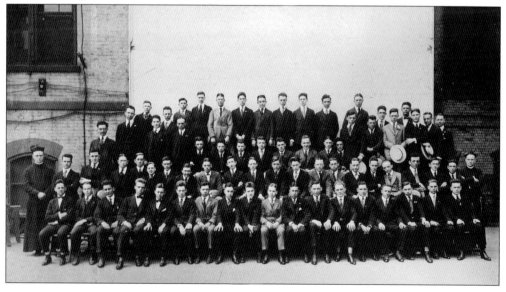

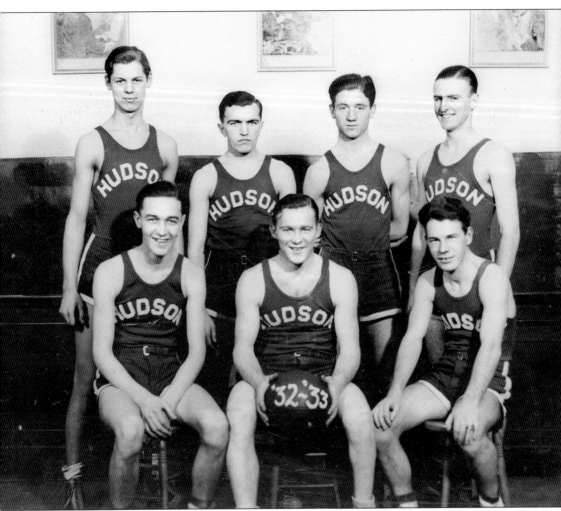

The 1930s were a busy time for Saint Peter's College athletics. When the College reopened in 1930, a freshman basketball team was initiated. It played 12 games and won four. In 1931, the team played a varsity schedule. The team's record in their first year of varsity play was 5-10. In their first three years, the team had three coaches and never had a winning record. In 1934, Morgan Sweetman took over the team and coached it until 1941. His record was 40-77. On November 23, 1932, Hudson College announced that it would start a basketball team. The team was called the Half Moons after the name of the explorer Henry Hudson's ship. By 1935, the teams were playing in the Collins Gym. Pictured here is the 1932–1933 Hudson College Half Moons.

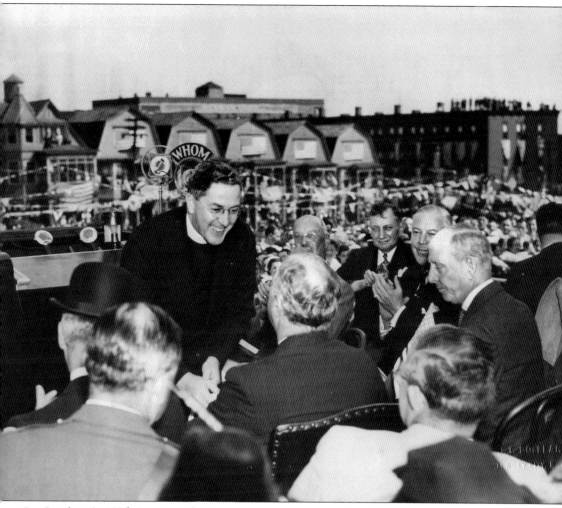

On October 2, 1936, Rev. Joseph Dinneen presented a scroll to Pres. Franklin D. Roosevelt. Roosevelt was no stranger to Jersey City. Frank Hague, the mayor of Jersey City from 1917 to 1947, was a supporter of Roosevelt's presidency and a prime factor in Roosevelt getting a large vote in New Jersey in the 1932 election. Before the election, Hague supported Alfred E. Smith as the Democratic Party's nomination for President. When Smith lost the nomination at the Democratic National Convention, Hague threw his support to Roosevelt. To appease Roosevelt, Hague offered to stage a rally for Roosevelt in New Jersey. Over 100,000 people made their way to the New Jersey Governor's Mansion at Sea Girt on August 27, 1932. Most of the attendees were bussed to the event from Hudson County by Hague. The rally made Hague an ally of Roosevelt for years to come.

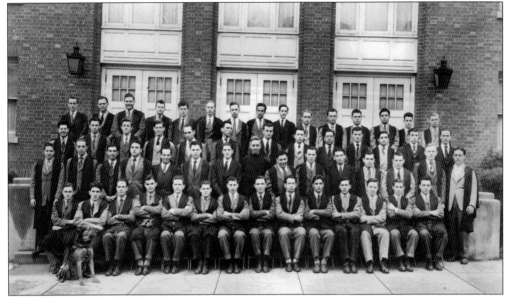

World War II had a significant impact on the college. Although the college did not have to close as it did during World War I, the enrollment suffered as many students enlisted or were drafted into military service. With declining enrollment came budget deficits and financial problems. By 1942, five hundred alumni were in service. Rev. Dennis J. Comey, S.J., president of the college from 1937 to 1943, made two changes in 1942. He ended post-graduate study and initiated an accelerated undergraduate program from four years to three for the duration of the war. For nearly all of the students in the 44th commencement ceremony in 1943, the future consisted of a tour of duty in the armed forces. Saint Peter's survived the war due to the combined effort of faculty, administrators, and students who worked to ensure the preservation of the college.

DISTRIBUTION OF COURSES
ACCELERATED CURRICULUM IN FORCE SEPTEMBER 8, 1942

| FRESHMAN | | Cr | SOPHOMORE | | Cr | JUNIOR | | Cr | SENIOR | | Cr |
L			L			L			L		
5	Latin	8	5	Latin	8	4	Logic	7	5	Ethics	9
5	Greek or Math.	8	5	Gk., Math., Bio.	8	4	Metaph.	7	5	Psych-Theod.	9
4	English	6	5	English	8	4	History	6	4	Elective 1	6
4	Modern Language	6	1	Public Speaking	2	4	Elective 1	6	4	Elective 2	6
2	Religion	2	3	Chemistry	6	4	Elective 2	6	2	Religion	2
			2	Religion	2	2	Religion	2			
20		30	21		34	22		34	20		32
4	English	6	4	English	6	4	Logic	7	5	Ethics	9
4	Modern Language	6	1	Public Speaking	2	4	Metaph.	7	5	Psych-Theod.	9
5	Math. or Bio.	8	3	Chemistry	8	4	History	6	3	Sci. Elect.	8
3	Chemistry	8	3	Physics	8	3	Sci. Elect.	8	4	Elective	6
2	Religion	2	5	Math. 1 or II	8	4	Elective	6	2	Religion	2
			2	Religion	2	2	Religion	2			
18		30	18		34	21		36	19		34
5	English	8	5	English	8	4	Logic	7	5	Ethics	9
4	Modern Language	6	1	Public Speaking	2	4	Metaph.	7	5	Psych-Theod.	9
4	History	6	4	History	6	4	Const. Hist.	6	4	Sociology	6
5	Math.	8	4	Economics I	6	4	Economics II	6	4	Elective 1	6
2	Religion	2	3	Chem. or Bio.	6	4	Elective	6	4	Elective 2	6
			2	Religion	2	2	Religion	2	2	Religion	2
20		30	19		30	22		34	24		38

March '45—Dec. '45	Dec. '45—Jun. '46	Sep. '46—March, '47	Mar. '47—Dec. '47
Eight terms of approximately 15 weeks each		Five class-days weekly of eight periods each	

L = Lecture hours; laboratory additional Cr = Academic credits or "semester hours"

Rev. Vincent J. Hart, S.J., (seated) succeeded Father Comey as president of Saint Peter's College in 1943. In addition to his duties as college president, Father Hart also served as rector of Saint Peter's Prep and pastor of Saint Peter's Church. Burdened with this workload, Father Hart managed to keep Saint Peter's College open throughout World War II. This was no simple task considering the circumstances. Facing a nearly impossible task, Father Hart turned over academic responsibilities to the dean and concentrated his efforts on the college's finances. Almost bankrupt, he turned to unorthodox means to keep it afloat by holding bingos, enrolling 35 women, increasing teaching loads, cutting teachers' pay, and receiving contributions from various groups. In the end, it all paid off. The college remained open until the war ended, and enrollments increased as men returned from the war.

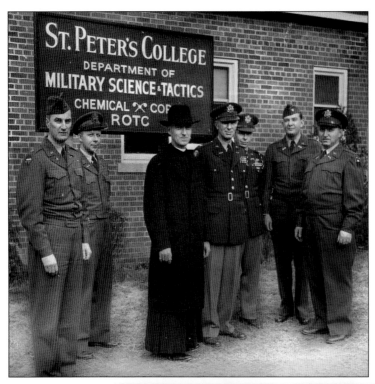

After World War II ended, the college's enrollment grew based on veterans returning to college. Saint Peter's was in need of space to accommodate the returning veterans and regular college-age students. In 1947, under the leadership of Rev. James Shanahan, S.J., (pictured) the college erected a one-story brick building called Memorial Hall. The building, which was located next to Collins Gym, was used as the home for the Department of Military Science and Tactics.

In 1949, the college's enrollment was growing, and the feeling on campus was upbeat. Rev. L. Augustin Grady, S.J., is holding one of the two live peacocks that were brought to the Saint Peter's College campus to celebrate its new prosperity. The peacocks were given a parcel of land between Gannon Hall and the Arts Building.

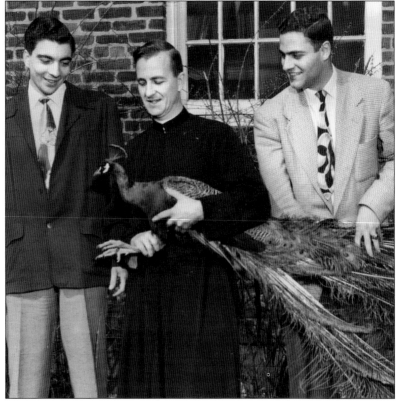

On October 28, 1949, Rev. James F. McDermott (far right), in the presence of Mayor John V. Kenny (far left), blessed the cornerstone of McDermott Hall. The three-story building on the corner of Glenwood Avenue and Hudson Boulevard (now Kennedy) gave the college the additional classroom space that it needed to meet the needs of its growing student enrollment.

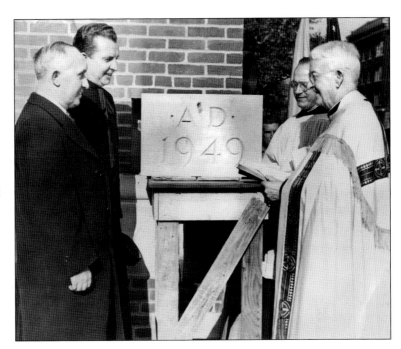

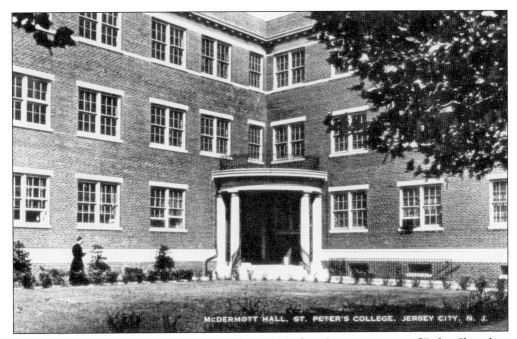

The completion of McDermott Hall occurred months before the appointment of Father Shanahan as president of the college. The building came just in time, because Father Shanahan had big plans for the development of the college. During his term as president, the college grew from 854 students in 1949 to 1,200 in 1956.

When World War II came to an end, Saint Peter's fortunes improved dramatically. Returning soldiers flocked to register at Saint Peter's College. In 1949, Rev. James Shanahan, S.J., succeeded Rev. Vincent Hart, S.J., as college president and was faced with a different, albeit happier challenge—how to deal with surging enrollment. At the close of the war in 1945, the student enrollment was 194. By the time Father Shanahan left Saint Peter's, the student body had increased by almost 1,000 percent. In 1951, he oversaw the establishment of the ROTC program; built Dinneen Hall (1956); purchased land on Glenwood Avenue and Hudson (Kennedy) Boulevard for the construction of Saint Peter's Hall (1958); and oversaw the acquisition of Rankin Hall (1959). During these years, Saint Peter's also saw the arrival of their literary magazine called *Pavan* (1949), and the *Pauw Wow* was returned to regular publication.

In June 1950, Saint Peter's College hired Don Kennedy (above, second from left; below, far left), a successful high school coach at Regis and Power Memorial high schools to take over a basketball program that at best could be called mediocre. In his 22 seasons as head coach, he compiled a record 325 wins and 190 losses. He brought speed, discipline, and a multitude of fundamental skills to the team's game. He was considered to be one of the best fundamentalists in the game and an expert on the fast-break offense. Kennedy elevated the Peacocks from the ranks of the basketball unknowns to a major college power. His teams received five National Invitational bids and won three Met Conference championships. In 1958, Kennedy was honored as the Catholic Coach of the Year and the team went to the National Invitation Tournament, only to lose in the first round.

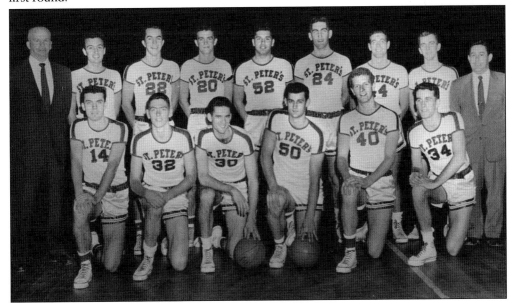

Saint Peter's College received its ROTC Chemical Unit in 1951. It used the Jersey City Armory for rifle practice, drill, and parade review. Rev. James Shanahan, S.J., a U.S. Army Air Force chaplain during World War II, was instrumental in establishing the unit at Saint Peter's and supported it throughout his tenure as president. The initial headquarters was a building on Montgomery Street, west of Memorial Hall. The ROTC had a long and controversial history at the college. Students who supported it did so strongly and with great pride. Those who opposed it did so on the grounds that military and academic interests are not served well in the same environment.

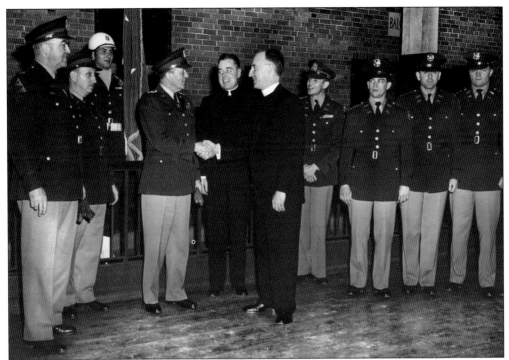

In 1951, Saint Peter's had 852 students. Some 600 were enrolled in the college's first ROTC. The program was compulsory for freshmen and sophomores. Juniors and seniors who were selected for advanced courses were required to attend six weeks at a summer military camp. Completion of the four-year course of studies qualified the student for a commission as a second lieutenant in the Officers Reserve Corps. Maj. Eugene Farrell of the Department of Military Science of Newark headed the staff. By 1959, of a total enrollment of 1,932 students, 839 were enrolled in the ROTC program. The program existed at the college until the 1990s.

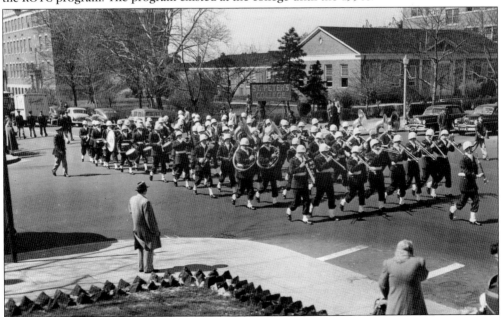

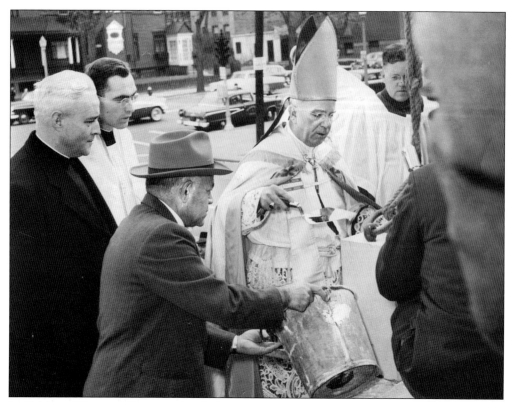

In 1957, Rev. Thomas Aloysius Boland, the Archbishop of Newark from 1952 to 1974, dedicated Dinneen Hall. Dinneen Hall was to be the last major classroom building erected at the college until Rev. Victor Yanitelli, S.J., became president in 1965. The building was designed to accommodate classrooms, administrative offices, and dining facilities. It was three times bigger than the Arts Building, which it replaced. Its four floors of mixed-use space were more than adequate to meet the needs of the increasing student population.

For many students in the late 1950s to the 1970s, Dinneen Hall was the center of activity. Before the building of dormitories, the dining halls in the basement of Dinneen Hall were where students ate but, more importantly, a place where students congregated and shared their stories of the day. Today Dinneen Hall is the home of Student Affairs, Campus Ministry, Community and Service Learning, Student Activities, and offices for various student organizations. It also has classrooms on the third floor. The building is named after Rev. Joseph Dinneen, S.J., president, fund-raiser, and builder of dreams.

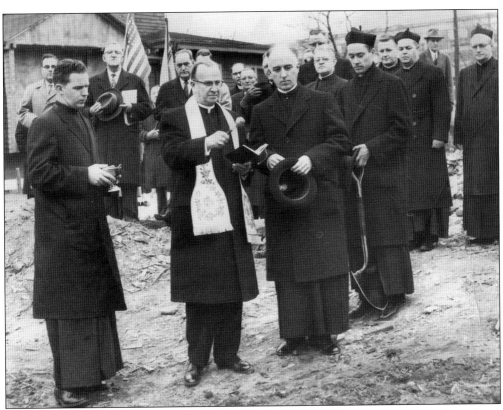

In September 1944, the college purchased a building across the boulevard from the college, which enabled the Jesuits to move out of the residence in Grand Street and set up a new one on the campus. The Jesuits lived in a house on the property until a new residence was built in 1959. On December 19, 1958, ground was broken for Saint Peter's Hall. Most Rev. Martin Stanton, the Auxiliary Bishop of Newark and alumnus of the class of 1919, blessed the ground. He was accompanied by Rev. James Shanahan, S.J. (holding hat). The building became the Jesuit residence until 1995 when it was converted into dormitories for sophomore students, a meeting hall, and office space for various administrative departments.

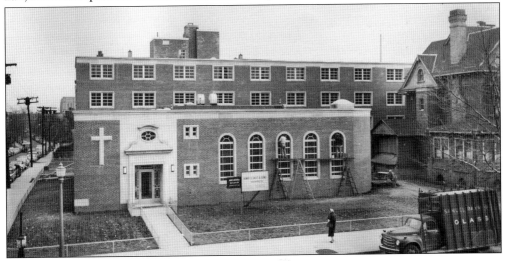

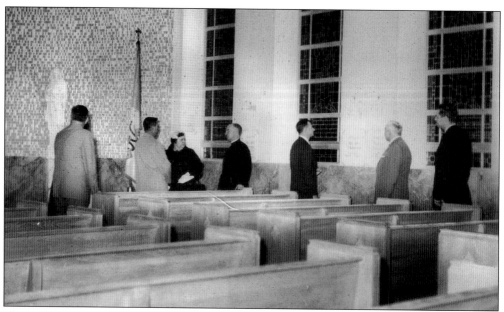

The centerpiece of Saint Peter's Hall was Saint Peter's Chapel. Renowned for its modern architecture and stained glass windows, the chapel served as the place of worship for the Jesuit community until 1994 when the Jesuits moved to 50 Glenwood Avenue. At that time, the chapel became the place of worship for the college. It replaced the college chapel, which for many years was in the lower level of McDermott Hall. The site of the former chapel has been renovated and is presently the college store. Today daily masses are celebrated in Saint Peter's Chapel for the local and college community.

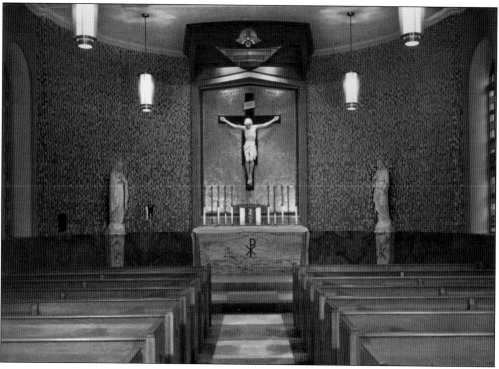

In February 1959, the college bought a former Buick dealership near the corner of Montgomery Street and West Side Avenue and renamed it Rankin Hall in honor of Rev. Richard Rush Rankin, S.J., (pictured at right), a graduate of the college who later joined the faculty in 1933. Card. Francis Joseph Spellman and Father Rankin dedicated the building. The first floor was converted into a rifle range for ROTC and the home of the Pershing Rifles, a military drill team. The second floor was used as classroom space. Today Rankin Hall is the home of the Fine Arts Department. The rifle range has been converted into a batting cage for the baseball team.

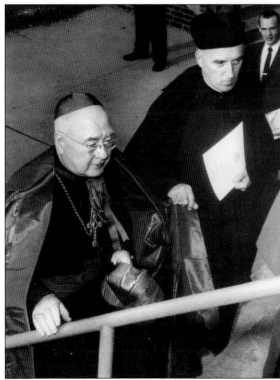

Saint Peter's College

announces

Liberal Arts Program
Evening Division

BEGINNING FALL SEMESTER 1960

Open to Men and Women

Six-year program with majors in History, English, and Economics. A minor in Education will also be offered.

For information write to:

Director of Admissions
St. Peter's College
Hudson Boulevard
Jersey City 6, N. J.

Note: All applicants are required to take the Scholastic Aptitude Test of the College Entrance Examination Board. The 1959-1960 College Board Examinations are scheduled for February 6th, March 12th, May 21st, and August 10th. Applicants must apply to the College Entrance Examination Board, P. O. Box 592, Princeton, New Jersey, at least a month prior to the examination.

Saint Peter's College first offered a liberal arts program for the evening division in the fall semester of 1960. Prior to this, only majors in accounting, management, and marketing had been offered for evening students. The courses were available to both male and female students. The new liberal arts program included majors in history, English, and economics and a minor in education. Today the evening division is known as the School of Professional and Continuing Studies. In addition to the majors in business administration, today evening students can major in criminal justice, elementary education, nursing, and professional studies. Over 63 percent of the students in the School of Professional and Continuing Studies are women. Saint Peter's is proud of its history of helping working adults obtain degrees, a tradition which dates back to the creation of Hudson College in 1932 by Rev. Robert Gannon.

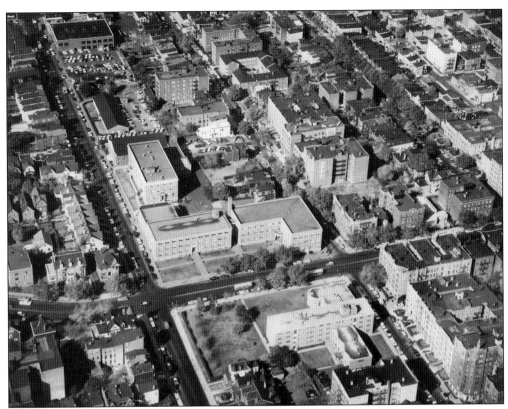

By the mid-1960s, four buildings—the Collins Gym, Gannon Hall, Dinneen Hall, and McDermott Hall—stood on the property that was once known as the Young Estate. Saint Peter's had firmly established itself as the college on the boulevard. The $200,000 investment in the property Rev. Joseph Dinneen made in 1933 proved to be a shrewd and intelligent move for the college. It was Father Dinneen's vision to make Saint Peter's College an institution with strong roots and a promising future, and Rev. James Shanahan's commitment to adhere to that vision, that enabled the college to grow and prosper on its new site.

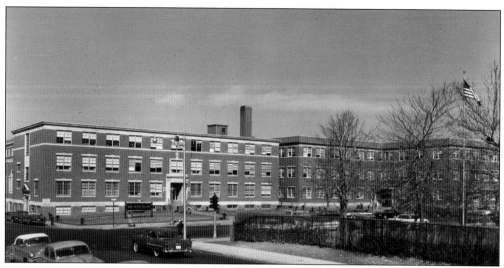

For the local community, McDermott Hall and Dinneen Hall were the face of Saint Peter's College throughout the 1960s and 1970s. Visible to all who traveled Hudson Boulevard, later Kennedy Boulevard, the red brick and limestone architectural style of the buildings symbolized the permanent position that the college had established in the Hudson County community. A college that, in the course of a little over 30 years, transformed itself from renting classroom space on the fourth floor of the Chamber of Commerce building on Newark Avenue to becoming a college campus with six major buildings. By 1966, the college had granted 6,775 degrees, 5,651 of them in the years between 1949 and 1966. There was never a question to the people that passed the college on their way to work or on their way home that Saint Peter's College ever would close again.

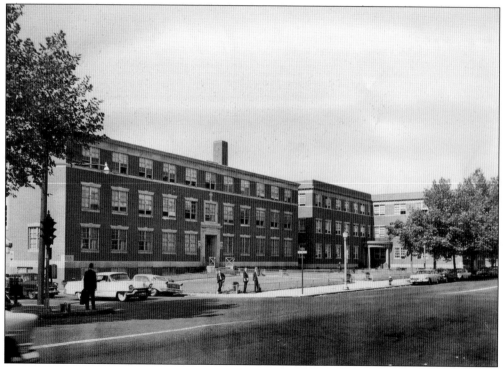

Three

BUILDING A
CAMPUS COMMUNITY

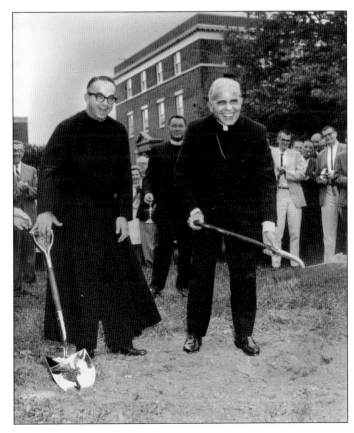

Rev. Victor Yanitelli, S.J., served an unprecedented 13 years as president of Saint Peter's College. Under his watchful eye, some of the greatest growth of the college took place. Here Father Yanitelli (left) is breaking ground for the Pope Academic Building with Bishop John J. Dougherty of the Newark Diocese on September 9, 1965.

Rev. Victor Yanitelli became the 18th president of the college in 1965. During his tenure, the student body doubled in size, degree programs expanded, and three new buildings were erected. He also opened the first branch campus outside Hudson County in Englewood Cliffs. In addition to his duties at the college, Father Yanitelli was on President Nixon's National Advisory Council on Economic Opportunity, chairman of New Jersey's Advisory Council on Educational Affairs, chairman of New Jersey's Advisory Council on Project Upward Bound, and treasurer of the New Jersey Association of Colleges and Universities. He was also a member of several organizations, including the New Jersey State Scholarship Commission, the Board of Governors of Jersey City's Chamber of Commerce, the Jersey City's Board of Education, the Hudson County Planning Board, Christ Hospital's Advisory Board, the Newark Archdiocesan Senate of Priests, the Board of Trustees of the Jersey City Boys Club, and the Youth Service Consultation Service of the Newark (Episcopal) Diocese. He was so popular that his supporters urged him to run for mayor of Jersey City in 1971, a request he declined.

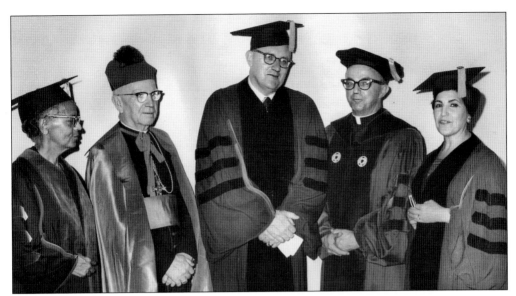

During Father Yanitelli's tenure as president of Saint Peter's College (1965–1978), many luminaries came to receive honorary degrees, including Lina Edwards, M.D. (far left); Mr. Mulligan (center); and Licia Albanese (far right). Dr. Edwards was a recipient of the Presidential Medal of Freedom, Albanese was a Metropolitan Opera star, and Mulligan was the dean of Fordham's Law School. Archbishop Thomas A. Boland presided at the commencement.

Saint Peter's campus has gone through several growth spurts. During the 1960s and 1970s, four buildings were completed: the Recreational Life Center, the O'Toole Library, the Pope Academic Building, and McIntyre Lounge. In this 1969 aerial photograph, the O'Toole Library and the McIntyre Lounge can be seen, as well as the Pope Academic Building, which was still under construction. Eventually the Recreational Life Center would be built and named for Father Yanitelli, Saint Peter's longest serving president.

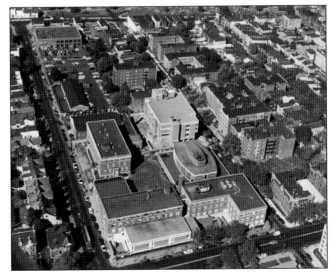

On a very hot day in September 1965, before 500 people crammed into Dinneen Auditorium and television cameras, Dr. Martin Luther King Jr. described his American dream. Dr. King spoke at the Michaelmas Convocation and was presented with an honorary degree of doctor of laws and letters. He denounced segregation as sinful and bitterly condemned those who profess the principals of democracy but in truth practiced the antithesis of these principals. He said the dream of all men being created equal has yet to be fulfilled. His message was simple: legislation alone will not change men's hearts, but we are all God's children and together we shall overcome. He rejected the notion that equal rights for all was a matter of time and the civil rights movement should move slowly. "The time is already now," he declared.

On October 16, 1965, to take part in a Model New Jersey State Assembly sponsored by the Political Science Form, 132 high school students and 42 faculty members from all over New Jersey descended upon Dinneen Auditorium. Gov. Richard Hughes (pictured) addressed the assembled students about the "Importance of the Executive in Legislation." Also addressing the students was Jersey City mayor Thomas Whelan.

U.S. senator Harrison Williams lectured at Saint Peter's on December 7, 1959. He was the first Democratic senator to represent New Jersey since 1958 and came to Saint Peter's College to discuss what he called "No Retreat from Responsibility." His concern was that people were too wrapped up in their personal lives and disengaged from broad national issues. He encouraged the audience to "get involved." The senator returned 11 years later during his reelection campaign in 1970.

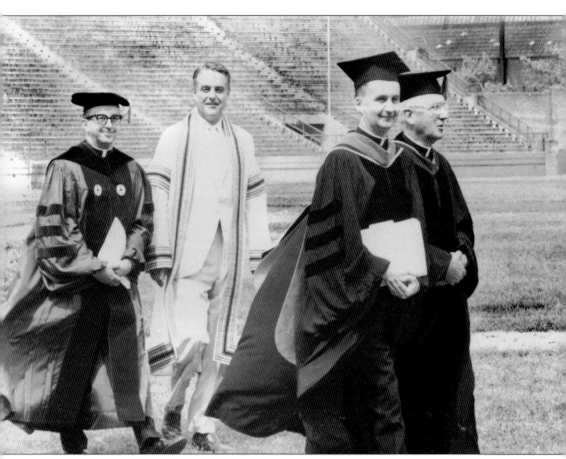

R. Sargent Shriver Jr. (second from left) was awarded an honorary degree at the 1966 commencement program and gave the keynote speech at the ceremony at Roosevelt Stadium. Shriver was an early opponent of World War II but volunteered for the U.S. Navy once America entered the war, saying he had a duty to serve his country even though he disagreed with its policies. This was the 35th honorary degree for the architect and first director and driving force behind the creation of the Peace Corps. Shriver also created the Office of Economic Opportunity, Head Start, VISTA, Job Corps, and the Special Olympics, just to name a few. He also served as the U.S. ambassador to France before running for vice president on George McGovern's ticket in 1972. Shriver was married to Eunice Kennedy, a sister of Pres. John F. Kennedy.

During the 1970s, the student body continued to grow, and need for more space became a necessity. In 1966, construction began on a student center in front of Dinneen and McDermott Halls. This new student center was dedicated to the memory of Capt. Charles F. McIntyre through the kindness of his beloved wife, Frances Cronin McIntyre. The facility was used as a student center and food court for almost 10 years until the college outgrew the space. In 2005, the facility was renovated and was redesigned as a multipurpose room. Today the space is used as a conference center, hosting various meetings, receptions, dinners, and events such as Career Day.

The 1960s were turbulent times on most college campuses, but Saint Peter's campus remained relatively claim. The most controversial event took place in 1966 when women began taking classes during the day. Although they had been attending the night session, it marked the first time they attended classes in the day session. Their male counterparts took to protesting, wearing buttons proclaiming, "This is a man's school." Below, five of the first women enrollees walk across campus in September 1966; From left to right, they are Margaret Lee, Ann Marie Narraro, Patricia Duncan, Patricia Briody, and Phyllis Amoroso. The women held their own, and the protest did not last long, quieting down in just a few weeks.

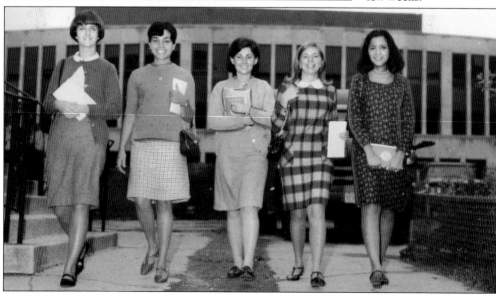

Saint Peter's garnered national attention for four weeks during the 1965–1966 school year. Students appeared on the General Electric program *College Bowl*. The team of Edward Boyno, John Reilly, John Harnett, and Tom Milkowski won the first three contests before losing their fourth. They defeated the College of St. Scholastica (315-30), the University of Hartford (360-50), and Rockford College (205-125) before losing to Earlham College (275-95). For their efforts, the team won $5,000 in scholarship money for Saint Peter's. They were not the only students to garner national attention on television. Theodore Bajo and Raymond Noble of the Gannon Debating Team debated Columbia University on the CBS television network program *College Counterpoint*. The team scored a victory for Saint Peter's College.

Retreat at
Gonzaga
Jan. 20 1966

Saint Peter's long tradition of spirituality has been a mainstay of student activities. The Saint Ignatius tradition of creating men (and women) for others, striving for social justice, and finding God in all things have been long-standing tenets of a Jesuit education. Faculty and administrators often join students on retreats in a variety of locations. Even during the turmoil of the 1960s, Saint Peter's continued to hold steady to its values. Perhaps it was because of this turmoil that students, faculty, and staff saw the importance of Saint Ignatius' values and continued to attend these retreats. Today several retreats are held every year. In this 1966 picture, the retreat took place at Gonzaga in Monroe, New York, on June 20, 1966.

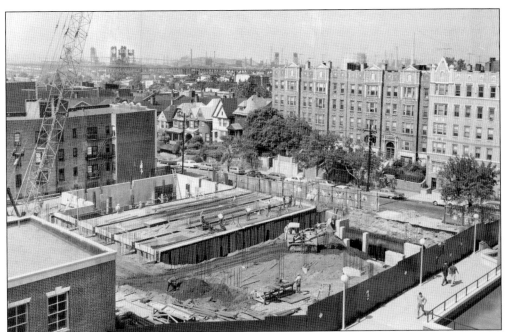

The Edward and Theresa O'Toole Library was constructed in 1967. The library has four levels that contain more then 50,000 square feet of space and more than 250,000 volumes. There are study stations, online catalog references, and phones to reach the reference, or circulation desks are available on each floor. The Englewood Cliffs Library has an additional 30,000 volumes, and together both libraries subscribe to 750 periodicals. In addition, the library subscribes to 70 major databases and has over 2,100 links to academic resources and governmental Internet sources. The reference area on the first floor is the library's busiest space where students can browse current journals and numerous bound periodicals, take advantage of database workstations, and obtain assistance from reference librarians. This area has a number of study stations for students to connect their laptops to the campus network.

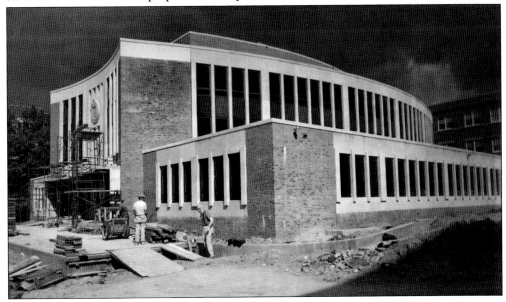

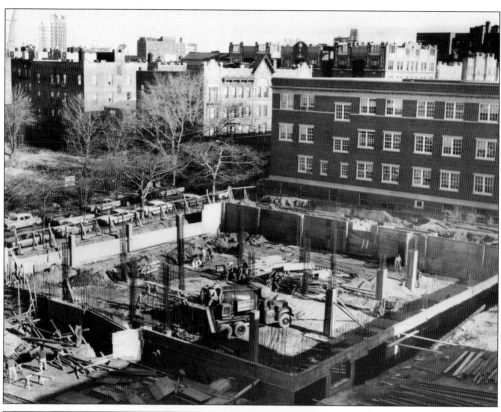

In 1967, the college joined the American Association of University Professors. Later that year, work began on a new academic building, Pope Hall, and in 1970, the Catherine and Generoso Pope Academic Building was opened. Seen here under construction, the building was dedicated on April 24, 1970. Pope Hall is the home of the newly renovated Pope Hall Lecture Theater, which has state-of-the-art multimedia capabilities. The 200-seat facility is a venue for many campus events, including the student film series and lectures with visiting scholars. Pope Hall also houses the college's television studio and numerous classrooms. Members of the Pope family were on hand for the dedication.

Richard Nixon made a campaign stop at Saint Peter's just before the 1968 election. Sponsored by the Young Republicans, the rally was held in Dinneen Auditorium, and like most political rallies, this one drew its share of protestors, but far more supporters than detractors wanted to hear Nixon speak. Tickets had to be issued, and to accommodate the overflow crowd, Nixon's speech was piped into the college cafeteria.

The Alumni Association lecture series sponsored a number of notable speakers and among them was Robert Moses (center). On December 2, 1966, Moses spoke in the McDermott Lounge about city planning. The architect of many New York City projects, including the 1964–1965 World's Fair, rejected the idea that there could not be solutions to complex urban problems. He said the only obstacle to successful urban planning was special interest groups who throw up road blocks for their own interests.

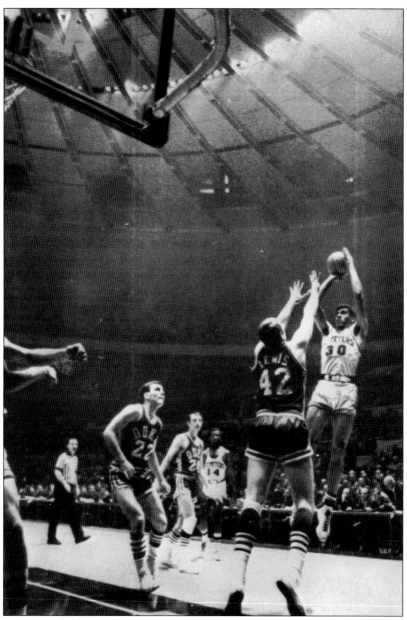

In 1968, under Don Kennedy, the Peacocks finished the regular season with a 24-4 record. This earned them a bid to the National Invitational Tournament (NIT). In the first round of the NIT, the Peacocks led by 51 points from Elnardo Webster and beat Marshall in two overtimes by a score of 102-93. Their next opponent was 10th ranked Duke University. Powered by the rebounding and scoring of Elnardo Webster and Pete O'Dea and the playmaking of Harry Laurie, the Peacocks defeated Duke 100-71 and advanced to the semifinal round of the tournament. The crowd of 19,500 was the largest to attend a college basketball game in New York at that time. Elnardo Webster scored 29 points and had 10 rebounds. Pete O'Dea scored 26 points and pulled down 11 rebounds as the Peacocks out rebounded the Blue Devils 58-46. The key to the Peacocks win was the intensity with which they played. Duke could not keep up with their speed and tenacity.

Ted Kennedy was recognized with an honorary degree at the 1967 Michaelmas Convocation. In his remarks, the first term senator spoke on the "generation gap" and stated that, unlike their parents, the current generation "welcomes dissent with an almost frightening thirst." In presenting the senator with his honorary degree, Fr. Edmund Ryan, S.J., said "fundamental virtues of courage, leadership and service were ideals made real by Senator Kennedy."

Julian Bond, the young Georgia legislator and civil rights advocate, spoke to students on May 8, 1969. More than 800 people crammed into Dinneen Auditorium to hear him speak, and before his prepared remarks about politics and race relations, he told the students "power concedes nothing without a demand, it never has and it never will." Moments after Bond's speech, Paul Lamb, the student senate president, called for a strike.

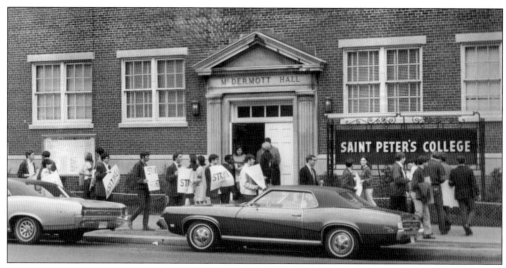

While turmoil was tearing apart college campuses across the country, Saint Peter's College remained relatively calm. However, the college could not totally escape the social revolution that was sweeping the nation. In 1968, students held their first public protest of the Saint Peter's administration. The initial issue was the dismissal of seven faculty members. The protests expanded to include the dress code and mandatory ROTC. The street protests moved inside when protestors occupied the office of Fr. Edmund G. Ryan, the college's executive vice president. On January 31, 1969, the students went on strike with about 160 students manning a picket line on Kennedy Boulevard. Although students also boycotted the cafeteria, not everyone supported the strike. An "anti-strike" was formed with almost as much support. Eventually, the dress code was relaxed and ROTC would no longer be mandatory. The seven professors, however, were not rehired.

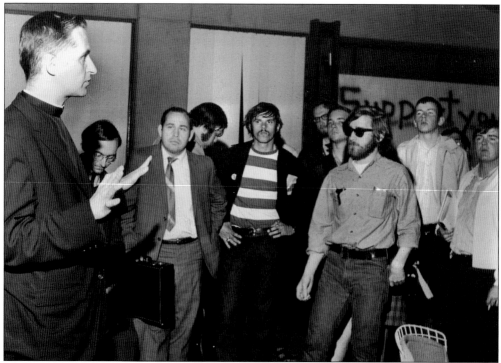

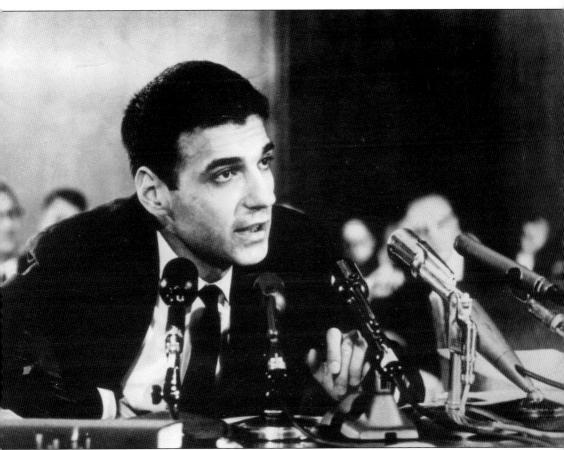

In January 1969, the student body hosted a lecture featuring Ralph Nader, the consumer advocate, and Mark Rudd, the student radical. While they may appear to be similar in their attacks against the "establishment," their styles were very different. Nader's rhetorical skills engaged the audience, while Rudd's presentation was dull, causing one observer to comment that Rudd could not "incite a box of kitchen matches, let alone a full-scale revolt." The nationally renowned champion of consumer rights, Nader returned to campus on October 2, 1974, to partake in a three-hour seminar. His lecture included topics concerning civil rights, consumer exploitation, and the power of the corporation. Born in Winsted, Connecticut, Nader graduated magna cum laude from Princeton University and initially made his reputation as a consumer advocate by investigating automobile safety and General Motors.

The decade of the 1960s came to a close with Saint Peter's conferring honorary degrees to two titans, William F. Buckley and Vince Lombardi (far left). Lombardi's fame began at St. Francis Prep in Brooklyn and grew when he became a member of Fordham's famed "Seven Blocks of Granite." Lombardi went on to become one of the most successful football coaches, including winning the first two Super Bowls ever played.

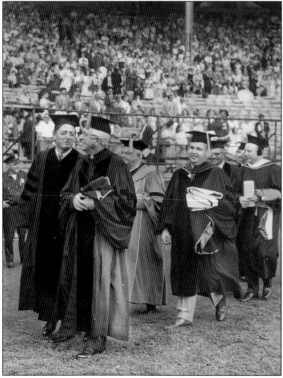

William Buckley Jr. (far left) appeared at Saint Peter's twice during the turbulent 1960s. On October 24, 1960, Buckley packed Dinneen Auditorium for his lecture. His conservative philosophy on the cold war stating that "co-existence breeds pacifism, pacifism breeds apathy, apathy breeds defeat," sparked strong reactions from both his supporters and detractors. Buckley returned to Saint Peter's to receive an honorary degree in 1969.

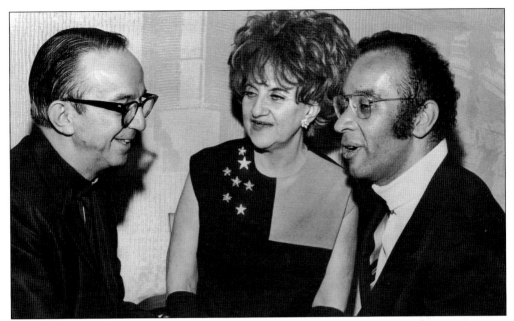

Saint Peter's College celebrated its centennial in 1972 with a program of activities that began in the fall of 1971 and lasted an entire year. On January 22, 1972, the New Jersey Symphony Orchestra performed a concert at Jersey City State College. Hermione Gingold served as narrator and Henry Lewis as the musical director; both are pictured here with Rev. Victor Yanitelli.

On February 1, 1972, Minnesota senator and presidential contender Eugene McCarthy joined a panel including Rev. Timothy Healy, S.J., vice-chancellor of City University of New York, and Dr. Ruth Adams, president of Wellesley College, to discuss current trends in the liberal arts in American colleges. The symposium was part of activities celebrating Saint Peter's 100th anniversary.

The noted historian, educator, author, and world traveler, Erik von Kuehnelt-Leddihn, spoke on October 10, 1972, as park of the yearlong centennial celebration. He blamed the destruction of cultural and religious traditions for many evils of modern society, including what he described as the "disease of student revolt." Some 30 years earlier, he was the chair of Saint Peter's History Department. Today he lives in his native Austria.

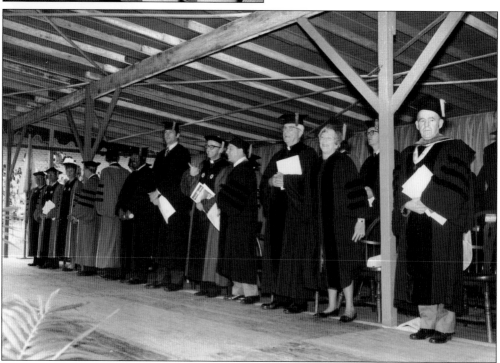

Long before he was a United States senator, Bill Bradley (tall man in the center) was a Princeton graduate, a Rhodes Scholar, and a forward for the New York Knicks. On May 27, 1973, he became a doctor of humane letters at Saint Peter's College. Bradley urged the graduates to commit themselves to something larger than themselves. He warned them that if they did not want another Watergate or Vietnam War, they had to get involved.

Growing enrollment placed strains on many of the college's facilities. One of the first major additions was the Recreational Life Center. Collins Gym could no longer support the burgeoning student body. In 1973, ground was broken for a new "life sports" center that could improve the college's intramural and intercollegiate athletic programs. Often referred to as the "Reek Center," the facility was named for Rev. Victor Yanitelli and has an Olympic-sized pool, three basketball courts, a racquetball court, an indoor golf practice facility, and a large roof "bubble" that houses five indoor tennis courts and a running track.

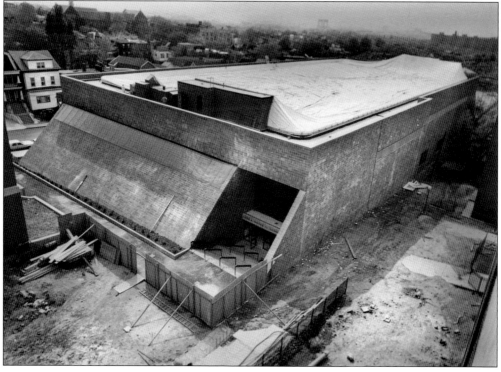

As one walks into the Recreational Life Center from the Quad, many probably do not notice the sculpture that sits above the entrance. It was crafted by Charles Vukovich, seen here with his sculpture in 1975 before it was mounted above the entrance to what is referred to today as the Reek Center. Made of copper, the large sculpture (measuring 24 feet by 17 feet) covers the entire wall above the entrance and represents Saint Peter, the fisherman. Vukovich, a resident of Maywood, New Jersey, graduated from the National Academy of Art in 1939 and had created several religious sculptures including the Stations of the Cross at both Saint Peter's Prep and Mount Manresa Retreat House on Staten Island, New York.

Nearly 10 years after her husband, Dr. Martin Luther King Jr., received an honorary degree from Saint Peter's College, widow Coretta Scott King came to campus. In the winter of 1975, she spoke in Pope Lecture Hall to a standing room–only crowd. She told the crowd that full employment would help to ease the country out of its economic inequalities.

During two days in April 1974, author and historian Arthur Schlesinger (center) spent time at Saint Peter's College. Remarkably, in one of his talks, he told his audience that "Richard Nixon will cease to be president." Four months later on August 9, 1974, Richard Nixon became the first president to resign his office. Schlesinger spoke about his new book, *The Imperial Presidency*, during his two-day visit.

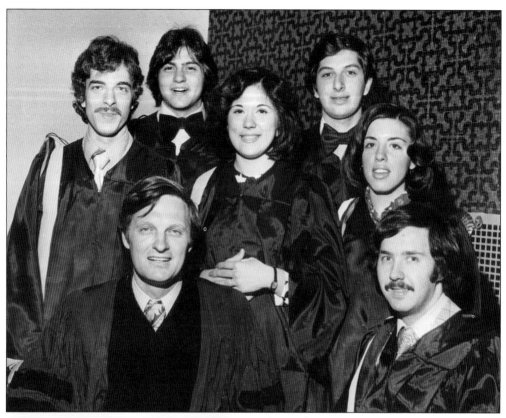

At the 1974 commencement ceremony, a television doctor became a real doctor (sort of). Alan Alda, star of the hit TV series *MASH*, received an honorary doctorate of humane letters. In his commencement address before 874 graduates, Alda urged them to maintain their sense of decency in their lives after graduation. "The moral character of this country is suffering because people are not providing decency in their own work and their own lives."

The only New Jersey appearance made by singer-song writer Judy Collins in 1975 was at the Recreational Life Center at Saint Peter's College. The tickets went for $4 for students with valid IDs, and general admission was $5. Collins began her career as a concert pianist and turned to singing and guitar playing. Like many musicians of her era, she was known for her strong pacifism.

The legendary actress Helen Hayes, along with Dr. Ruth Adams (vice president of Dartmouth College) and Nicholas Marcalus (president of Marcal Paper Mills), was to receive an honorary degree at the 1975 commencement program before 700 graduates. Unfortunately, due to an illness, the award-winning actress was unable to attend the ceremony, so Rev. Victor Yanitelli went to the hospital to present Hayes with her honorary degree.

Joseph Papp, who was one of the most influential producers in American theater, spoke at Saint Peter's about the necessity of relating urban drama to the lives of young people and refreshing Shakespearean drama to suit contemporary times. During his remarks, Papp, who is buried on Staten Island, often lashed out at critics who have blasted his work, in particular Clive Barnes.

The three-time Academy Award winning director Frank Capra came to Saint Peter's for two days of lectures and interviews. Capra began his career as a prop man in silent films. The first film he directed was *It Happened One Night* with Clark Gabel and Claudette Colbert and went on to make such hits as *It's A Wonderful Life, Mr. Smith Goes to Washington, You Can't Take It With You, Arsenic and Old Lace*, and *Lost Horizon*. One of the greatest names in American filmmaking offered his insights into the art of making movies to the students at the college. Although daring and controversial in his own right, Capra decried the trend towards pornography, violence, and disaster movies and predicted that they would be passing trends. Capra died in 1991. Unfortunately his prediction about the future of films did not come true.

Four

CONTINUING
THE TRADITION

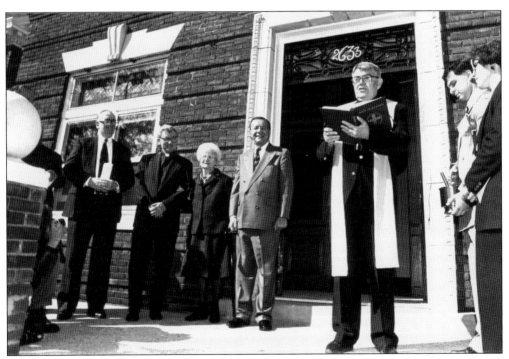

In 1994, a gift from Congressman Frank J. Guarini (center) enabled the college buy a house on the corner of Montgomery Street and Kennedy Boulevard. The house was named the Guarini House and today serves as the residence for the president of the college. In addition, the college established the Guarini Center of Governmental Affairs.

By the 1970s, Saint Peter's was growing by leaps and bounds. In order to meet demand for the college's programs, the first satellite campus was established at Englewood Cliffs in 1975. Primarily designed to meet the needs of adult students, Englewood Cliffs campus offers an array of programs for both undergraduate and graduate students. The degree offerings include bachelor degrees in nursing, business administration, criminal justice, and elementary education. The graduate program includes master degrees in education, nursing, business, and accountancy. Situated in Bergen County, the property was leased from the Sisters of St. Joseph of Peace in Englewood and marked the first time Saint Peter's had a presence outside Hudson County. Day and evening sessions were offered until 1983 when day sessions were eliminated.

Saint Peter's College's Jesuit commitment to serve others continues to attract students from every walk of life. Student organizations such as *Men and Women for Others* work to provide personal care for those in need under the guidance of the office of campus ministry. In the spirit of Saint Ignatius, founder of the Jesuits, the staff of campus ministry provides a person-centered environment. Since faith, service, and sensitivity to issues of justice flow from one another, campus ministry works closely with the office of community service and service learning, Saint Peter's Pax Christi Social Justice Community and the Social Justice Program. Saint Peter's College calls its students to become "men and women for others" and encourages them "to find God in all things." The staff offers programs, celebrations, and personal support that help to meet the religious, spiritual, and social needs of the campus community.

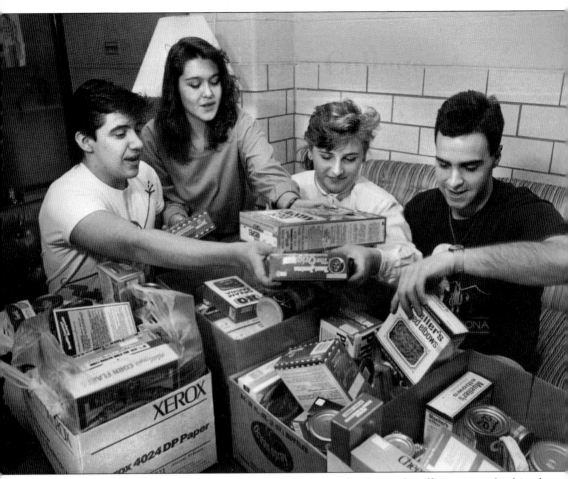

The mission of Saint Peter's is to encourage students, faculty, and staff to get involved in the community by fund-raising or helping out those who need a hand. The college sponsors many events, trips, and rallies in which members of the college community can get involved. An important component of these events is that it brings people together who want to work to change the way the world looks today. "Perhaps the most important thing to understand, is that one group can have a huge impact on the world, and our society will always be a part of that experience," Dr. Cornacchia said in his inaugural address. "This past year alone, 60 percent of our students volunteered in 45 agencies, programs, and schools. Saint Peter's students and faculty contributed more than 16,500 hours of service. Each of them began their own personal journey towards being 'men and women for others.'" Here members of People United Against Hunger and Homelessness participate in a food drive. Pictured from left to right are Marco Coba, Tammy Guadagno, Antoinette Cllello, and Gregory David.

Playing his first game in Yanitelli Center on November 27, 2002, Saint Peter's College freshman Kendren "Kiki" Clark set a building record with 44 points in the Peacock's 94-85 win over St. Francis, New York. In four seasons, from 2002 to 2006, Kiki scored 3,058 points. He became the sixth player in NCAA Division I history to reach 3,000 points. In 2003, he was named the Met Writer's Rookie of the Year. He was on the All-Met first team every year he played at the college. In 2005, Kiki became the first player in Saint Peter's history to be given the Haggerty Award as the best Division I Men's Basketball Player in the Metropolitan Area. He holds Saint Peter's College records in points scored, scoring average, field goals, three-point field goals, and free throws.

Student organizations sponsor a variety of event on campus from the serious to the not so serious. The not-so-serious events included a "Mr. Legs" contest sponsored by Gamma Sigma Sigma, the college's first sorority. The contest was held in Dinneen Auditorium on November 9, 1968, following the Jersey City State v. Saint Peter's College football game and was won by a rather large football player. A bodybuilding contest (above) was held in 1997, and the Black Action Committee sponsored a fashion show (below) seen here also in 1997. Today students carry on this tradition with such events as Showtime at SPC and Speed Dating (Class of 2010).

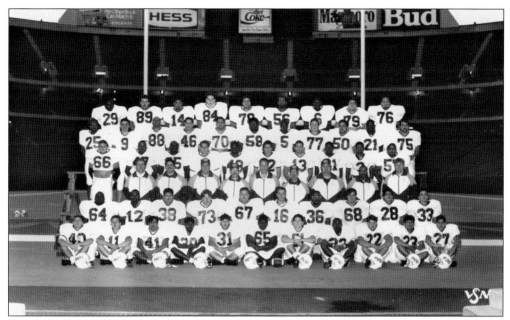

After almost 50 years, Saint Peter's once again fielded a football team in 1965 at the club level. In 1971, the program moved to NCAA Division III. The team was suspended in 1984 and 1988 for a lack of players. In their last year competing in division III, the Peacocks compiled an impressive 7-2 record. The Peacocks went division I-AA in 1993 when the NCAA passed legislation prohibiting division I programs from having sports below division I. Joe Coviello coached the team from 1974 to 1978 to a 20-20 record over five seasons. The Peacocks' most successful year was in 2001 when the Rob Stern–coached team led the nation at the NCAA Division I-AA level in scoring defense, total defense, passing defense, and turnover margin. Football was eliminated in 2007.

The 1960s brought a number of social changes to the campus. One of the most significant to student life was the dress code. They had voted in 1968, 927-189, to relax the code. Men had been required to wear a white shirt and tie with black or brown shoes and a jacket. Freshmen wore blue and white beanies and seniors wore sleeveless black knee-length robes.

Although Saint Peter's College is in an urban setting, students still find places to relax away from the maddening crowds. This student is sitting on a knoll outside Gannon Hall. The wireless network allows students to study and do their work almost anywhere on campus. In addition, the campus offers over 300 computers in 20 labs, including mini-labs in residence halls.

On June 10, 1996, Madeleine Albright, the United States ambassador to the United Nations, delivered an address discussing United States foreign policy interests. Then United States representative Bob Menendez '76 introduced Albright to a capacity crowd in the Roy Irving Theater. In her remarks, Albright discussed areas of long-standing conflict in such places as Cuba, Cyprus, and Northern Ireland.

In 1982, graduation was held in the Brendan Byrne Meadowlands Arena on June 5. That year honorary degrees were conferred on Roland Smith, co-anchor of CBS television evening news, and John Thompson, Georgetown University's basketball coach. Smith, who also gave the commencement address, would return to Saint Peter's College on October 23, 1990, to moderate Saint Peter's first national telecast from the Roy Irving Theater. The telecast was broadcast via national satellite. From left to right are Eileen L. Polani, Edward Reuter, Roland Smith, and Rev. Edward Brandy, S.J.

In 1887, an Alumni Association of Saint Peter's College High School graduates was formed although there had not been a Saint Peter's College graduation. The association was started mainly as an act of alumni solidarity. It was not a very active group. In 1905, some of the college's graduates got together to reinstitute the almost defunct Alumni Association. With the cooperation of Rev. Joseph Ziegler, S.J., a new constitution was adopted in November. The objectives of the constitution were to strengthen friendships made at the college, create a mutual assistance network, and promote Saint Peter's College to the local and wider community. Today the alumni association has 4,200 registered members and sponsors over 20 events annually. The events include reunions, fund-raisers, family days, and a homecoming celebration. All of the events are conducted in the spirit of the mission of the 1905 Alumni Association constitution.

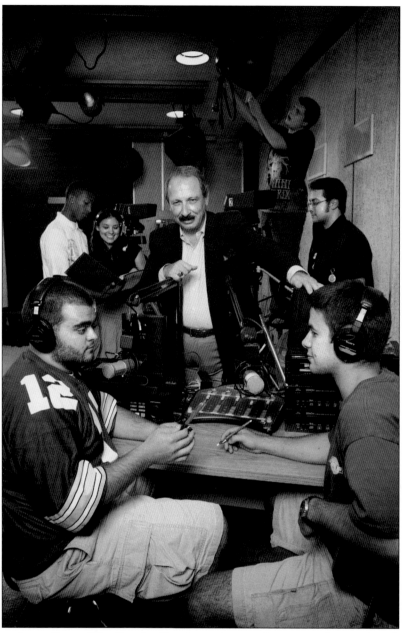

Like many other colleges, Saint Peter's offers its students various ways of expressing themselves using both the ink and electronic medias. The Saint Peter's student newspaper and magazine have a long tradition at the college. In 1969, a new tradition began when Saint Peter's took to the airwaves. The original studio was located in a small closet in the Instructional Resource Center in Rankin Hall. The studio was moved several times until it reached its current location on the second floor of Pope Hall. The station is staffed by volunteer student disc jockeys under the supervision of the Communications Department. More than half of the disc jockeys are musicians. On October 2, 2006, WSPC expanded its operations when they began broadcasting over the Internet. Its first Internet broadcast aired on October 2, 2006. Professor Joseph Lamachia (center) serves as the station manager, and Dr. Barna W. Donovan is the moderator.

One of the most significant changes to campus life came in 1983 when the first residence hall opened. After a protracted battle in the city council, 146–152 Glenwood Avenue apartment complex was converted to a student dormitory. Today the student residence is known as Veterans Memorial Court. With resident students, activities could be expanded. These after-class activities encouraged students to remain on campus, changing student life at Saint Peter's forever.

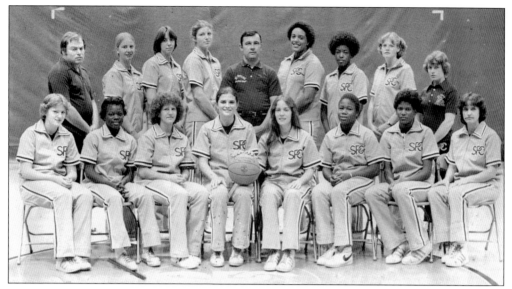

Mike Granelli served as the head women's basketball coach at Saint Peter's College from 1972 to 2004. He posted a 607-249 record during his 32-year career. He is 1 of just 20 coaches in the history of women's basketball to win more than 600 games and one of only six to do so at just one school. The Peahens made seven NCAA Division I tournament appearances during Granelli's tenure. The 1980 Peahens finished the season with a 27-4 record. In 1997, the Peahens posted a 25-4 record, were the Metro Atlantic Athletic Conference (MAAC) regular season and tournament champs, and received an NCAA Tournament bid. During a 24-season span starting in 1978, the Peahens reached the 17-win plateau 23 of 24 times. Since the beginning of the MAAC, the Peahens have won 10 regular season and 9 postseason MAAC titles.

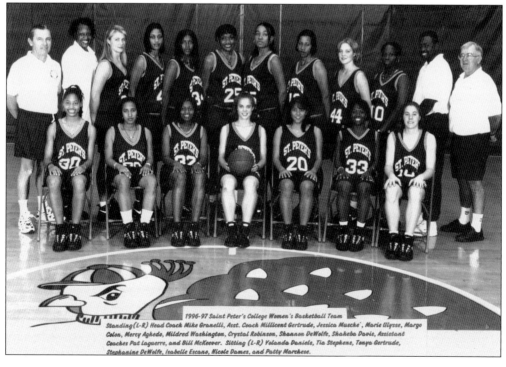

1996-97 Saint Peter's College Women's Basketball Team
Standing (l-R) Head Coach Mike Granelli, Asst. Coach Millicent Gertrude, Jessica Musche', Marie Ulysse, Margo Colon, Mercy Aghedo, Mildred Washington, Crystal Robinson, Shannon DeWolfe, Shakeba Davis, Assistant Coaches Pat Laguerre, and Bill McKeever. Sitting (L-R) Yolanda Daniels, Tia Stephens, Tonya Gertrude, Stephanine DeWolfe, Isabelle Escano, Nicole Dames, and Patty Marchese.

At the urging of Dr. Patrick Caulfield, the Jesuit Provincial gave Saint Peter's College permission to start a full-time Education Department in 1958. In 1979, with the support of Rev. Edward Glynn, S.J., Dr. Caulfield established a graduate program in education. Until his retirement in 1988, "Doc" Caulfield served as the director. In 2009, building on the success of the undergraduate and graduate programs, the college established a formal school of education to help meet the growing education needs locally in Hudson County and throughout New Jersey. The school of education offers certification programs in five areas: educational leadership, reading, teaching, special education, and counseling.

In 1983, replacing color-coded cards and manual student records, computers took over the long process of student registration. Standing with Rev. L. Edward Glynn, S.J., the college president, is Dr. Alessandro Calianese (center), the first director of the college's computer center. Dr. Calianese was also the director of the MBA program in management information systems, the second graduate degree program at Saint Peter's. Today all classrooms have Internet access and most are "smart" classrooms. The students have access to more than 300 computers in 20 labs as well as a mini-lab in most residence halls. These mini-labs are available to the students 24 hours a day, seven days a week.

Saint Peter's College began a baccalaureate degree program for registered nurses in 1982. The first director of the program was Dr. Doris Collins, seen here with students in a class in 1985 (below). The program offered the combination of the Jesuit tradition of caring for others with state-of-the-art technology. This combination proved very successful and the program became very popular and continued to grow. In 2006, the program offered the first generic bachelor of science degree in nursing (BSN) program in Hudson County. After 27 years of success, the college created a school of nursing in 2009 to accommodate the demand for this critical profession.

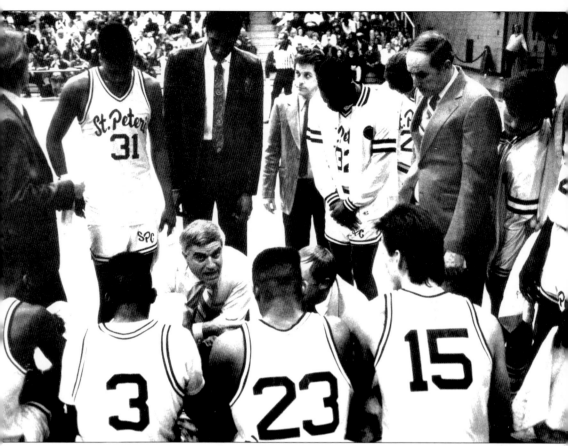

In 1986, Ted Fiore was hired as the Saint Peter's College men's basketball coach. In his nine years at the college, his teams won 151 games and lost 110. The Peacocks won the MAAC regular season championship in his first year as coach. In 1991 and 1995, his teams won the MAAC Championship Tournament. In 1991, the Peacocks, led by Tony Walker, Marvin Andrews, and Jasper Walker, traveled to Dayton to play Texas. The final score had Saint Peter's on the losing side by 73-64. In 1995, the team traveled to Albany to play University of Massachusetts, which was coached by a young John Calipari and starred Marcus Camby. In their second NCAA playoff game, the Peacocks again fell short of a victory. The final score of 68-51 was not indicative of the hard fought close game that the Peacocks, led by Luis Arrosa, Randy Holmes, and Mike Frensley, played. The University of Massachusetts held the Peacocks scoreless in the final 11 minutes and pulled ahead at the end of the game.

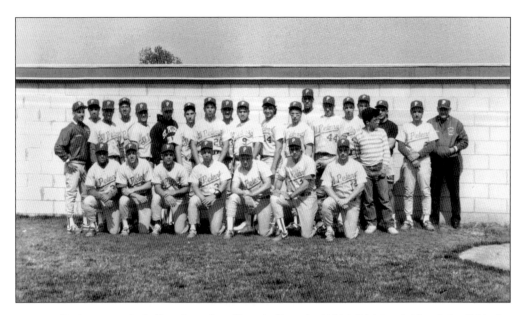

Since 1969, Saint Peter's College has played baseball on the NCAA Division I-A level. In 1980, the college entered the MAAC as a founding member along with the U.S. Military Academy, Fairfield University, Fordham University, Iona College, and Manhattan College. Today the conference has 10 members. Until the building of Jaroschak Field in the late 1990s, the baseball team played its home games at Caven Point Field in Jersey City. The field, which has been renamed Cochrane Field, is on the New Jersey waterfront in the shadow of the former World Trade Center. Since 1969, the team has a win-loss record of 451-903.

Whelan Hall was the first building on campus that was constructed specifically as a student residence hall. It opened its doors in 1993 to incoming freshmen and, along with Saint Peter's Hall, established the heart of the east campus. The new residence hall houses 185 students. The project was made possible by the generosity of Thomas Whelan, who graduated from Saint Peter's in 1968, with a personal donation of $1 million, the largest single gift to the college. The building, on the corner of Montgomery Street and Kennedy Boulevard, was named in honor of his parents, Florence and John Whelan.

In 2008, the 1994 men's baseball team was inducted into the Saint Peter's College Hall of Fame. The team ended the 1994 regular season with an 18-22 record and went to the MAAC Tournament. They beat Canisius 7-6 and swept LeMoyne 7-1 and 6-4 to win the tournament. The team had a potent offense and strong pitching staff. Chris Pini set the Saint Peter's College single season record with 64 hits. Drew Brown set the single season record for doubles and RBI. Chris Nocera scored 45 runs and Rick Ranft lead the team with a .407 batting average. Chris Del Preore led the pitching staff. In 1994, opposing batters hit .162 against him. The team was coached by Bruce Sabatini, a participant in the Little League World Series for a semi-final West New York team and an outstanding college player at Holy Cross.

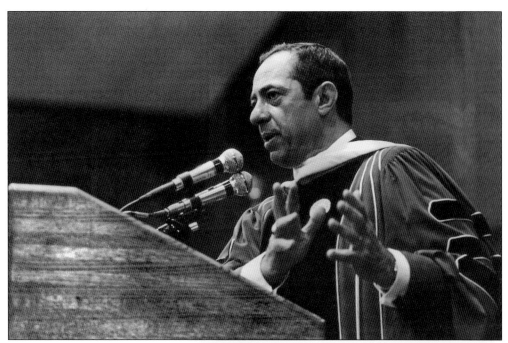

During 1985, Saint Peter's College sponsored a series of lectures entitled Prophets and Profit. Speaking before a crowd of 1,500 in the Yanitelli Recreational Life Center, New York governor Mario Cuomo said, "We have an obligation to bring what we believe to bear on the mundane activities our day-to-day lives, a duty not just to put up with the world but to live in it, to love, to re-create it."

At the Founders' Day Convocation, April 21, 1986, Malcolm Forbes received an honorary degree. The publisher of Forbes Magazine served as a New Jersey State Senator (1951–1958). The decorated World War II veteran also failed in an attempt to become governor. In his remarks, Forbes said that "the goal of a college should not be to fill minds with specific exam answers but rather to excite young people and encourage them to inquire."

The college's theater was named in honor of Roy Irving, a professor and professional actor. He began his acting career in Dublin and came to the United States after World War II. While working with Claire Bloom and many other prominent actors on and off-Broadway, Professor Irving became director of the Argus Eyes Drama Society and served in that capacity from 1948 to 1989. Located on the first floor of Dinneen Hall, the theater can seat 500 people for a variety of events. In addition to Argus Eyes productions, the facility also hosts the annual Michaelmas Convocation, career and wellness fairs, club fairs, lectures, and other student, faculty, and staff events.

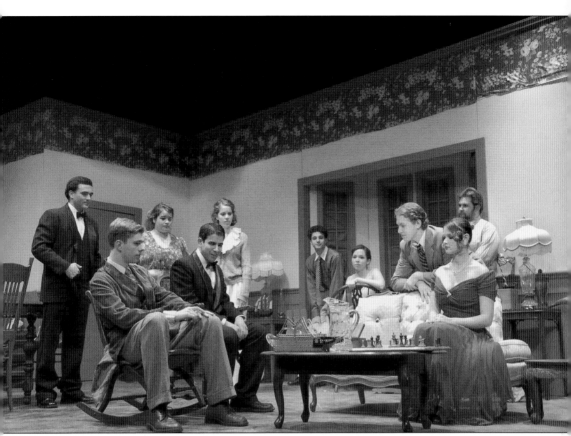

The Argus Eyes Play Club met for the first time on December 12, 1913. Its first public performance was on January 14, 1934, with three one-act plays. At the time, the college was exclusively men. The roles of women were played by the men of the college. Today Argus Eyes performs twice a year. The mission of the organization has remained the same for over 75 years. Argus Eyes hopes to foster excitement and awareness for the arts. In the spirit of "Cura Personalis," it nurtures imagination and creativity. The students who participate in the plays gain an appreciation for the diversity of the human condition and, through their performances, build an awareness of themselves. The audiences who attend the plays are introduced to many of the great dramas, comedies, and musicals in the theater canon and are enriched by the performances of the student actors. Above is a 2007 student production of *You Can't Take It With You.*

Over the years, Jesuits have been the guiding force of Saint Peter's College. During those years however, the number of Jesuits has diminished, and the college has had to depend more and more on lay faculty. Nevertheless, the college has been committed to offering the best liberal arts education possible, remaining faithful to the values of Saint Ignatius, and maintaining a student faculty ratio of approximately 16:1. Through the commitment and dedication of everyone at the college, they have been able to continue its strong Jesuit traditions and commitment to "education one student at a time." Some 22 Jesuits, including those who have retired, remain part of the Saint Peter's community and now reside in the Gothic Towers on Glenwood Avenue. The Jesuits moved from their home in Saint Peter's Hall where they lived from 1960 to 1994.

Five

THE NEW MILLENNIUM

In 2006, Saint Peter's College and Jersey City joined together to build a bridge to link the east and west campuses. The bridge, conceived in 1996, was a joint effort between Hudson County, Jersey City, the State of New Jersey, and Saint Peter's College. Dedicated on October 16, 2004, the bridge provides a safe and secure means of crossing the very busy Kennedy Boulevard.

The fall of 2001 was a very somber time for the country. People all around the world felt the pain of the terrorist attacks on the World Trade Center and the Pentagon. To commemorate those from Hudson County and the Saint Peter's College community who lost their lives in the September 11, 2001, attack, a plaque was dedicated to their memory. Affixed to the west tower of the pedestrian bridge crossing Kennedy Boulevard, the plaque was a joint effort between the college, Hudson County executive Thomas DeGise (sixth from the left), and the Board of Chosen Freeholders. On the sixth anniversary of the attack, Thomas DeGise (1972) joined the college in dedicating the plaque.

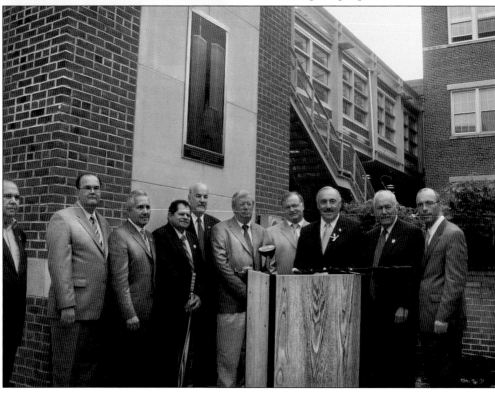

Millennium Hall is the newest residence hall. Located at 806 Montgomery Street, the building was named in celebration of the new millennium and the future of Saint Peter's College. Built in 1999, the facility is used as a freshman residence hall. Located on the east campus, next to Whelan Hall, Millennium Hall is "wired" for internet access and features several student lounges and a computer lab. The residence hall is four stories high and can accommodate up to 175 students. In 2004, a bridge was constructed joining the east and west campuses. The bridge provides a safe alternative for students crossing busy Kennedy Boulevard to attend their classes on the west campus.

The arts are alive and well at Saint Peter's College. In a scene from a recent performance of *Cabaret*, the cast strikes their pose. The performers are, from left to right, Lauren Buzzelli, Amanda Staub, Jolevette Mitchell, Dominic Furina, Kate Hopkins, and Faye Rosario. The Argus Eyes Drama Society has been performing for audiences since the group was founded by Rev. Robert Gannon in the 1930s.

Although some of the faces have changed over the years, enthusiasm and school spirit remain high among the students. One of Saint Peter's strengths is its diverse student body. Students from all over the United States as well as 60 foreign countries come together to learn from each other as well as the faculty.

The Quad was originally constructed as the focal point of the (west) campus, connecting the original three buildings: Gannon Hall, the Arts Building, and Collins Gym. The Quad got its first face-lift in 1976 when the grass was replaced with concrete, complete with park benches, trees, and gardens. Over the years, several other buildings have been built around the Quad, including Pope Academic Building (1970), the Edward and Theresa O'Toole Library (1967), and the Yanitelli Recreational Life Center (1973). Rankin Hall remains one of the few academic buildings not directly connected to the Quad. In 2006, the Quad underwent another renovation. It continues to remain the focal point for the west campus and plays host to many student activities.

Clubs continue to be an important part of life at Saint Peter's College. In these 2008 photographs, students participate in the annual Club Fair. The fair has something for everyone, and it brings hundreds of students to the Quad where they can learn about and join dozens of club. Sponsored and supported by the students, these clubs offer the opportunity to explore the arts, student government, academic interest, and the diverse cultures of the world while making friends and mastering new skills. This annual event is sponsored and supported by the students and has grown in popularity through the years.

A sculpture of Saint Peter was erected in front of Whelan Hall on Kennedy Boulevard in honor of the college's namesake. It remind the students of the Petrean values that foster the human respect and integrity needed for people to live, work, study, and interact as a learning community of Saint Peter's College. The project was financed by an anonymous benefactor and created by Brian P. Hanlon of Tom's River. Hanlon is commonly known as "New Jersey's Sculptor." Since 1991, he has fashioned over 200 public art pieces. Mostly known for creating memorials to civic leaders and public servants, Hanlon also has a large number of liturgical pieces and tributes to sports heroes in his vast catalogue of work.

In October 2008, Saint Peter's College became the first academic institution in New Jersey to serve as the base for an Order of the Sons of Italy in America lodge—the newly formed Fr. Victor R. Yanitelli, S.J., Lodge No. 2847. The lodge name honors the first Italian American president (1965–1978) of Saint Peter's College, who had an enormous impact on the college and Jersey City. Father Yanitelli was the longest serving president of Saint Peter's College.

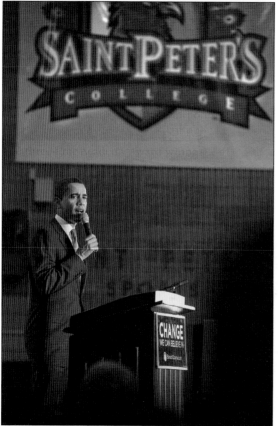

The college has played host to varying politicians, including Richard Nixon and Eugene McCarthy. This Jesuit tradition continued to be strong in the new millennium. In January of 2008, candidate Barack Obama delivered one of his campaign speeches in the Recreational Life Center promoting his theme of change.

The Business Symposium has provided a forum for the discussion of current events in business and politics since its inception in 1972. The oldest continuous Symposium of its kind in New Jersey, this event attracts approximately 350 of the area's top business and political leaders, and provides Saint Peter's students with the opportunity to network with the business community. Over the past 35 years, the Business Symposium has evolved into one of the signature events of both the college and the community. In 2003, three past governors appeared together, including former governor Brendan Byrne (1974–1982), Thomas Kean (1982–1990), and James Florio (1990–1994). Past speakers include Bob Woodward (below in sunglasses), Pete Hamill, Paul Begala, and Geraldine Ferraro.

Rev. Philip F. Berrigan, S.J., spoke before a capacity crowd in McDermott Lounge on November 20, 1967. He, along with his brother Daniel, was a very controversial priest who opposed the war in Vietnam as immoral and against the Christian conscience. He also felt that the Catholic Church was failing its role as a moral leader for adapting the same views as businessmen, the government, and education. Daniel (pictured above) returned to Saint Peter's in 2006 to help dedicate a building to a long-standing Jesuit ideal, social justice. Dr. Anna Brown (pictured below standing on the porch at right) was the moving force behind establishing the King-Kairos Social Justice House and is the program's coordinator. The house is located at 125 Glenwood Avenue.

In 2003, the Saint Peter's men's soccer team finished the regular season with a 14-4-2 record and headed to the MAAC Tournament where they defeated Loyola 2-1. The Peacocks headed to Brown University for the first round of the NCAA Tournament. The game was a defensive struggle, as no teams scored in the first half. Rinaldo Chambers scored twice in the second half and the Peacocks won 2-0. The victory meant that Saint Peter's would travel to Ann Arbor, Michigan, to play the No. 12 nationally ranked Michigan team. The Peacocks' Cinderella season ended in a 6-2 loss at the hands of the bigger and faster Wolverines. The 2007 Peacocks (pictured above) headed back to the MAAC Championship in 2007. Their opponent in the games was Loyola, the team they beat in 2003 to advance to the NCAA Tournament. This time, Loyola won, and the Peacocks had to wait until the last name was called for an at-large bid to the NCAA Tournament to advance. They traveled to Virginia where they were defeated by the Cavaliers, 3-1.

Although Saint Peter's College is a small liberal arts college, it does not lack for big ideas. Research led by Drs. Jose L. Lopez and Wei-Dong Zhu (pictured above) in the field of microplasma earned the college a $2 million grant from the U.S. Department of Defense in 2008. The grant will be used to create the Center for Microplasma Science and Technology. This center is the first and only one of its kind in the nation devoted entirely to the study of microplasma. Saint Peter's will serve as the hub for all other research in this field across the country and will host scientific meetings and workshops.

One thing that has not changed over the years is the smiling faces on graduation day. In 2008, commencement took place in the PNC Bank Arts Center with 795 students graduating: 21 Associates, 455 Bachelors and 319 Masters. The number of graduates has fluctuated over the years. In 1990, only 507 students graduated, while in 2008 the largest number of students ever to graduate now calls Saint Peter's their alma mater.

In 2008, Saint Peter's College entered a new era when Dr. Eugene J. Cornacchia was appointed the 22nd and first lay president. Dr. Cornacchia's career at Saint Peter's College spans more than 25 years. During that time, he served in several capacities including faculty member of the Political Science Department, chairman of the Political Science Department, academic dean, vice president for Academic Affairs, and college provost. Dr. Cornacchia led initiatives that increased enrollment while significantly raising academic standards. In his inaugural address, Dr. Cornacchia pledged to continue the Jesuit tradition of faith, service, and commitment to social justice. Below, Dr. Cornacchia is pictured with his wife, AnnMarie (left), and his two daughters, Katherine (center) and Lauren, at his inauguration.

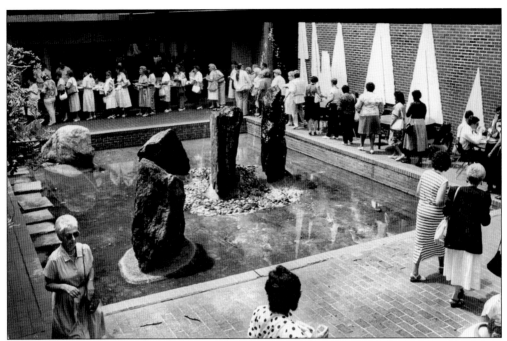

One of the many improvements to the campus came to the fountain outside the College Store and Advising Center in 2009. Originally constructed in 1972, both students and staff have used this location for a variety of activities. As part of the ongoing improvements to the campus, this area was transformed into a beautiful setting with a landscaped water fountain, benches, and bistro-style tables. Among the many uses of this site has been the annual Feast of Saint Ignatius (pictured above). Open to the entire Saint Peter's community, the feast celebrates the life of the founder of the Society of Jesus and is accompanied by mass in Saint Peter's Chapel followed by a barbeque.

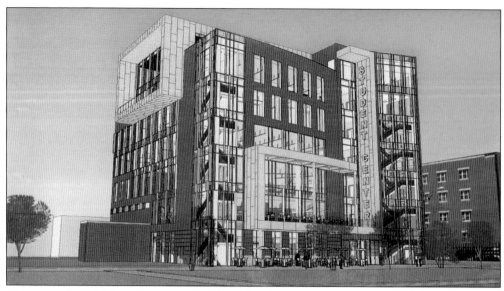

The anchor for Saint Peter's strategic building plan for the new millennium is a proposed student center. Estimated at $40 million, the center will provide much needed room for existing student activities and Jesuit mission and identity events, as well as additional space for new programs. The center will be built on the existing parking lot behind Millennium Hall on Montgomery Street.

In 2009, BMW Mini Cooper and the federal government offered a special program to government and nonprofit organizations. In an effort to road test electric cars, a low-priced leasing program was made available to organizations in New York, New Jersey, and California. Saint Peter's College, in its continuing effort to support the "greening" of Jersey City, agreed to participate in the program and is now testing two Mini Cooper electric cars. (Courtesy of David Bryngil.)

The study abroad programs bring students to the far reaches of the globe. These students earn academic credit while studying overseas. Academic year, semester, summer, and short-term programs are available for all majors. Here students stand in Tiananmen Square on the trip to China in 2008. Dr. Jon Boshart led this trip, which also included a visit to Xian, China. Other programs took students to Mexico, Italy, Ireland, Australia, France, Scotland, and England. In the photograph below, Dr. Karl Alorbi (second from left) is with his class in Edinburgh, Scotland, in 2007. The gentlemen wearing the kilts are, from left to right, Ravi Shah, Raul Zepeda, and Shadi Badran. This course also included a visit to London. (Above, courtesy of Steve Smith; below, courtesy of Karl Alorbi.)

www.arcadiapublishing.com

Discover books about the town where you grew up, the cities where your friends and families live, the town where your parents met, or even that retirement spot you've been dreaming about. Our Web site provides history lovers with exclusive deals, advanced notification about new titles, e-mail alerts of author events, and much more.

MADE IN THE USA

Arcadia Publishing, the leading local history publisher in the United States, is committed to making history accessible and meaningful through publishing books that celebrate and preserve the heritage of America's people and places. Consistent with our mission to preserve history on a local level, this book was printed in South Carolina on American-made paper and manufactured entirely in the United States.

This book carries the accredited Forest Stewardship Council (FSC) label and is printed on 100 percent FSC-certified paper. Products carrying the FSC label are independently certified to assure consumers that they come from forests that are managed to meet the social, economic, and ecological needs of present and future generations.

FSC
Mixed Sources
Product group from well-managed
forests and other controlled sources

Cert no. SW-COC-001530
www.fsc.org
© 1996 Forest Stewardship Council

Find Your Place in History.